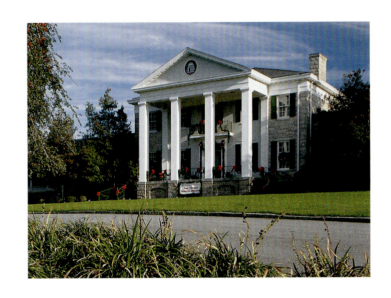

GEORGIA

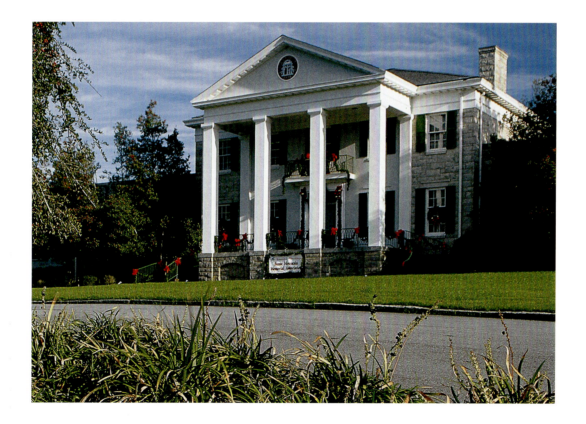

WHITECAP BOOKS

Copyright © 2002 by Whitecap Books Ltd.

Second printing, 2005

All rights reserved. No part of this publication may be reproduced, stored in a retrieval system, or transmitted in any form or by any means, electronic, mechanical, photocopying, recording or otherwise, without prior written permission of the publisher.

The information in this book is true and complete to the best of our knowledge. All recommendations are made without guarantee on the part of the author or Whitecap Books Ltd. The author and publisher disclaim any liability in connection with the use of this information. For additional information please contact Whitecap Books Ltd., 351 Lynn Avenue, North Vancouver, BC V7J 2C4.

Text by Tanya Lloyd Kyi
Edited by Elaine Jones
Photo editing by Tanya Lloyd Kyi
Proofread by Lisa Collins
Cover and interior layout by Jacqui Thomas

Printed and bound in Canada

National Library of Canada Cataloguing in Publication Data

Kyi, Tanya Lloyd, 1973–
 Georgia

 (America series)
 ISBN 1-55285-325-X

 1. Georgia—Pictorial works. I. Title. II. Series: Kyi, Tanya Lloyd, 1973- America series.
F287.K94 2002 975.8'044'0222 C2002-910075-5

The publisher acknowledges the financial support of the Government of Canada through the Book Publishing Industry Development Program for our publishing activities.

For more information on the America Series and other Whitecap Books titles, please visit our web site at www.whitecap.ca.

Picture these diverse images: the plush parlor of a nineteenth-century mansion with antique British chairs clustered around a marble fireplace; wind-sculpted oaks jutting from the borders of a white sand beach; the night skyline of a twenty-first-century city whose skyscrapers bear the names of the world's most powerful corporations. These three scenes are so different they might be found in separate corners of the world, yet each is unmistakably a part of Georgia. This is a state of contrasts.

Perhaps such contrasts were born even before Georgia became a state. The mixed influences of the indigenous people and the Spanish, French, and British explorers and colonists left their marks. Unlike in many regions, the farmers and colonists of Georgia lived peacefully with the native peoples, sharing knowledge and traditions, at least until the nineteenth-century discovery of gold in the northern mountains. While some communities grew around grist mills, others boasted railway stations, lighthouses, or cotton gins.

The differences between communities and regions were later cemented with the Civil War and the capture of Atlanta by General Sherman in 1864. Sherman's Union troops destroyed the city, torching military outposts and razing neighborhoods. The army of 60,000 then cut a wide swath of destruction along its way to Savannah and the Atlantic coast. The communities that were destroyed, most memorably Atlanta, had to start over, and a new era of commercial success slowly began. The communities still intact after the march were suddenly in possession of a rare resource—history. The squares and mansions of Savannah have been carefully preserved since Sherman departed, as if a close brush with destruction reinforced their value.

Whatever its roots, the diversity that now defines Georgia can be seen in the attractions that beckon thousands of visitors to the state each year. Some drive the Antebellum Trail from Athens to Macon, touring the state's cotton-era history. Some take to the streets of Atlanta, wandering past the legacies of the 1996 Olympic Games. Others explore beach resorts, golf courses, and national forests. In Georgia, you can escape into history and escape to the beach all in one day.

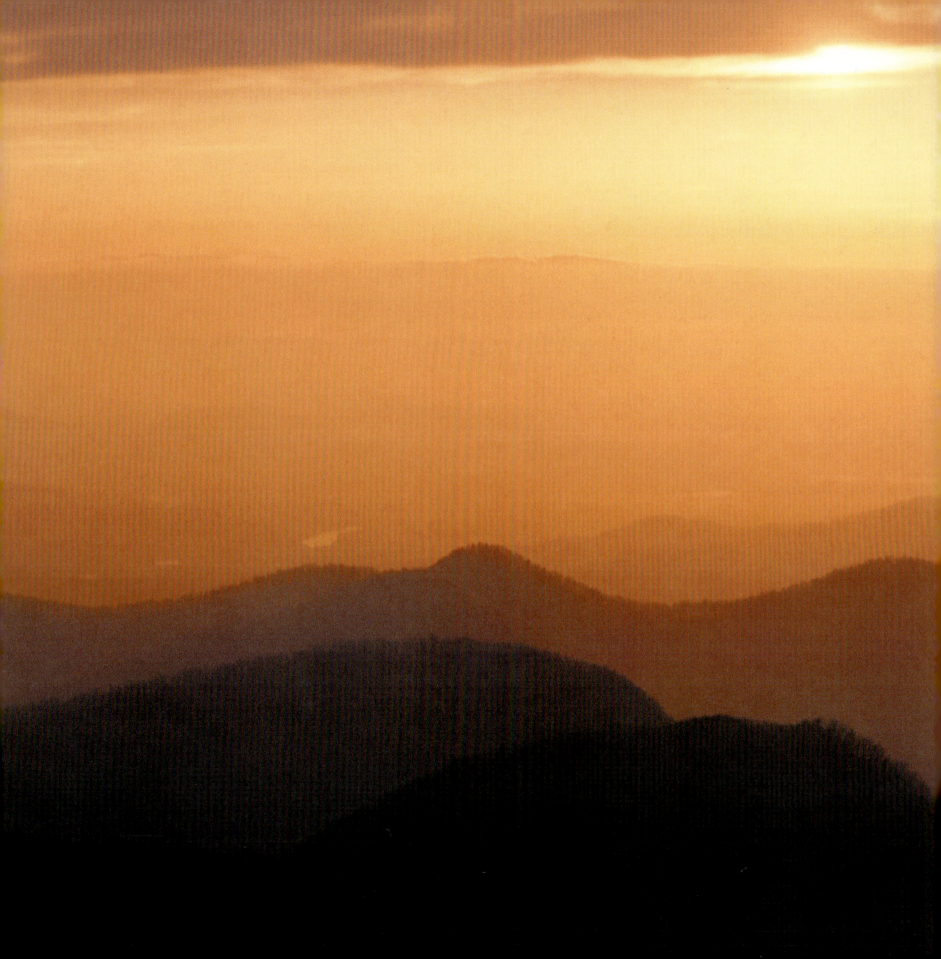

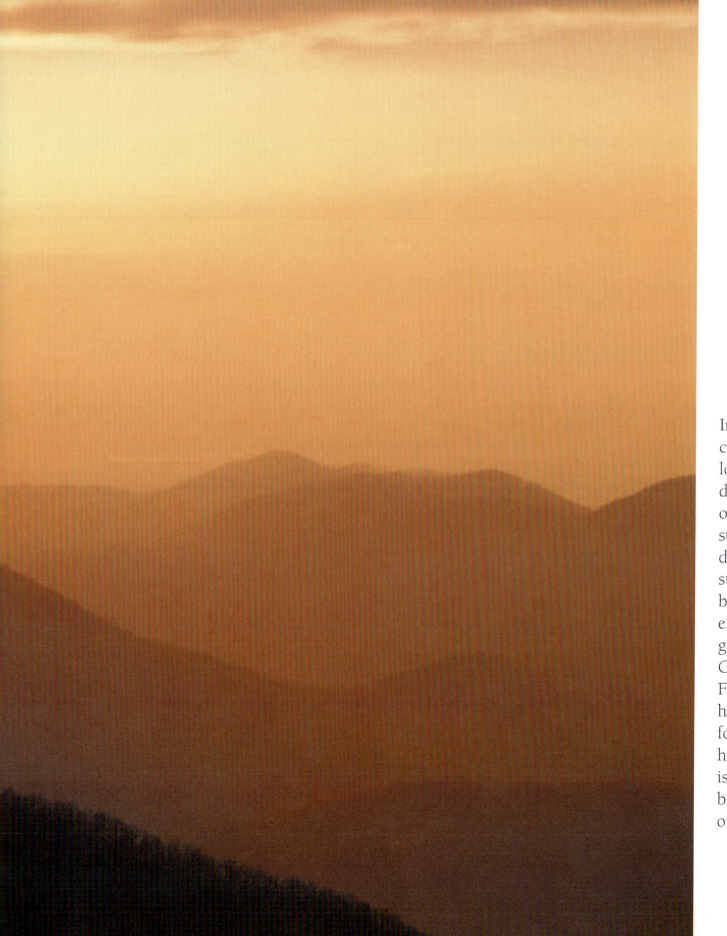

In the nineteenth century, homesteading, logging, and mining devastated the forests of northern Georgia, stripping the land and driving wildlife species such as deer and black bear to the edge of extinction. Since the government established Chattahoochee National Forest in 1936, officials have worked to replant forests and restore habitat. The region is now home to a black bear population of more than 600.

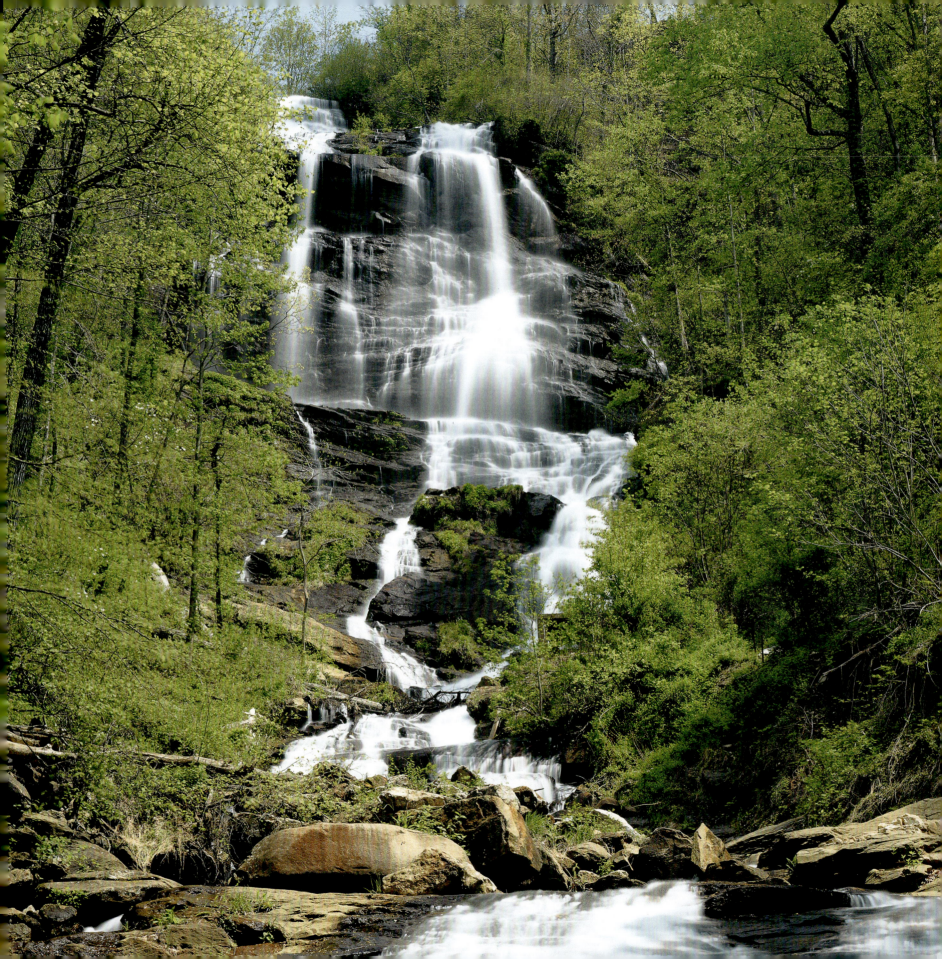

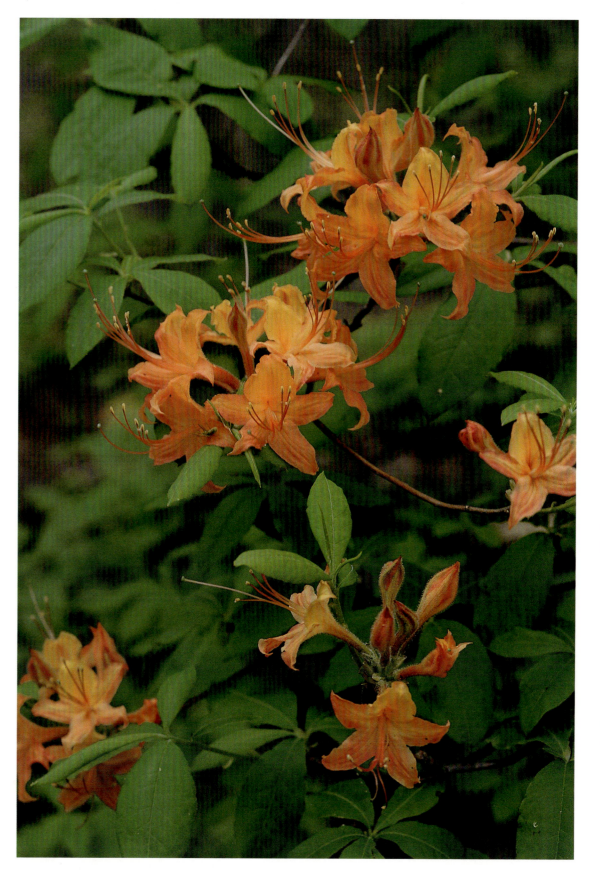

Wild flowers bloom in Chattahoochee National Forest. When the first European settlers arrived to clear the forests near the Chattahoochee River, the local Cherokee and Creek peoples studied their farming practices and the groups coexisted peacefully. With the discovery of gold in the local creeks, however, the native people were driven from the land to join the "Trail of Tears" migration to Oklahoma, a journey that killed thousands.

FACING PAGE—
Amicalola Falls State Park in northern Georgia preserves 2,050 acres of lush hardwood forest. Its centerpiece, Amicalola Falls, is the highest waterfall east of the Mississippi Mountains, cascading 729 feet into a churning pool below.

Toccoa Falls, a 186-foot cascade in northern Georgia, draws visitors to the campus of Toccoa Falls College, a Christian school founded in 1907. For the 950 students on campus, the falls also offer a quick escape from academic life.

Facing Page—
Fort Mountain State Park is named for the remains of a rock wall located at the top of the mountain. Historians believe it was created by the Woodland native people in about A.D. 500, perhaps as part of a religious structure. But local legend tells of a Welsh prince named Medoc, who arrived in the sixteenth century and created a fort atop the peak.

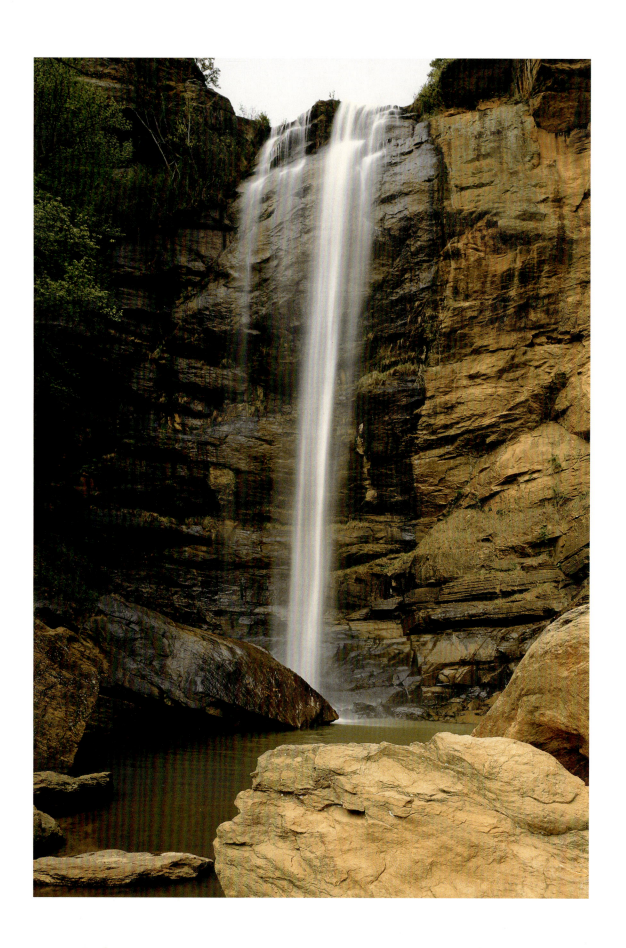

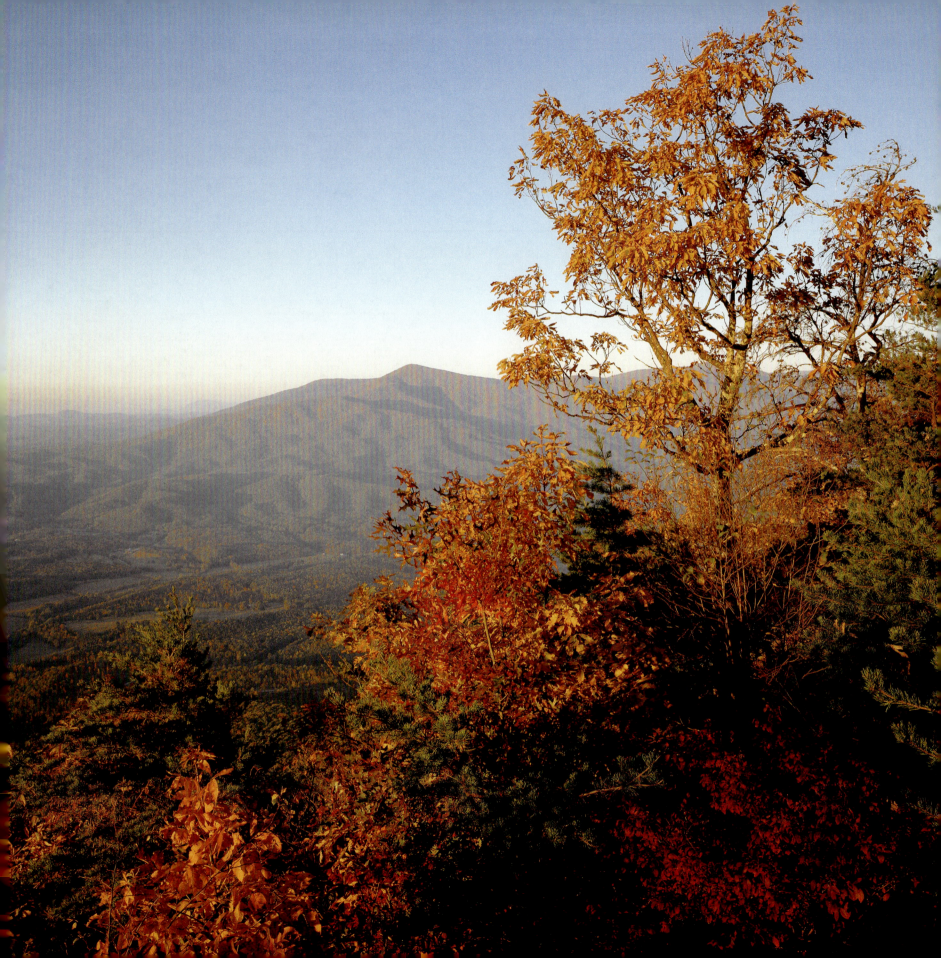

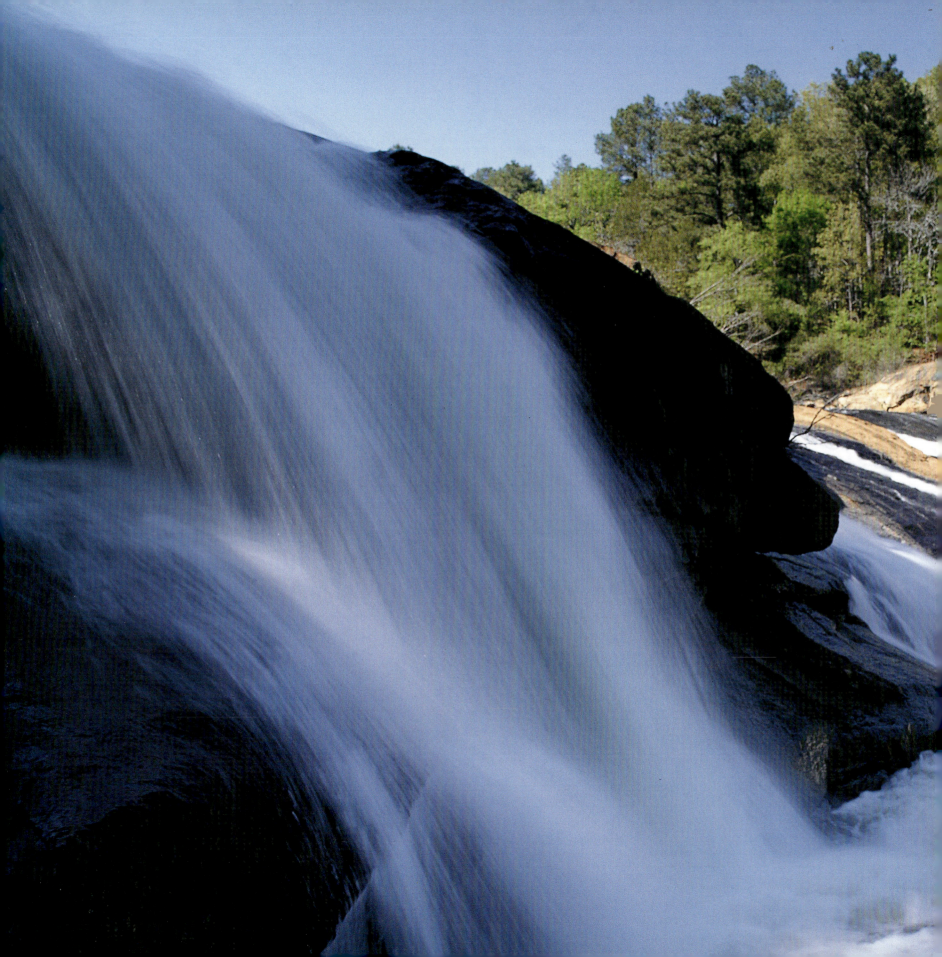

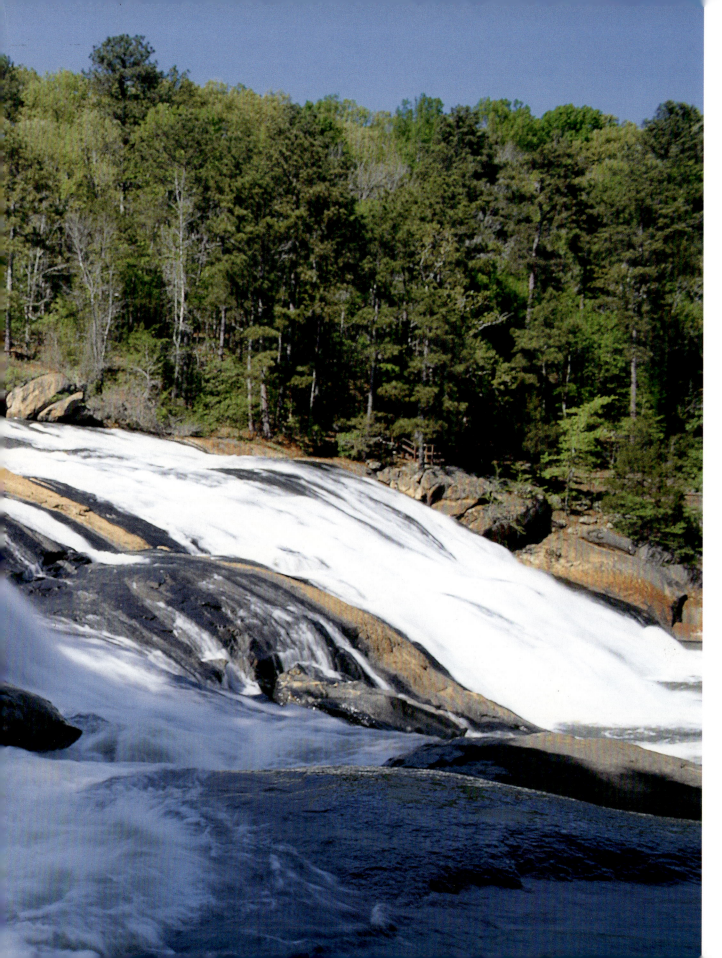

Two hundred years ago, there was a bustling town near this site, with working mills and factories. When the railroad bypassed High Falls in the late nineteenth century, the settlement was abandoned. Today, High Falls State Park offers more than 100 campsites and a hiking trail to the ghost town.

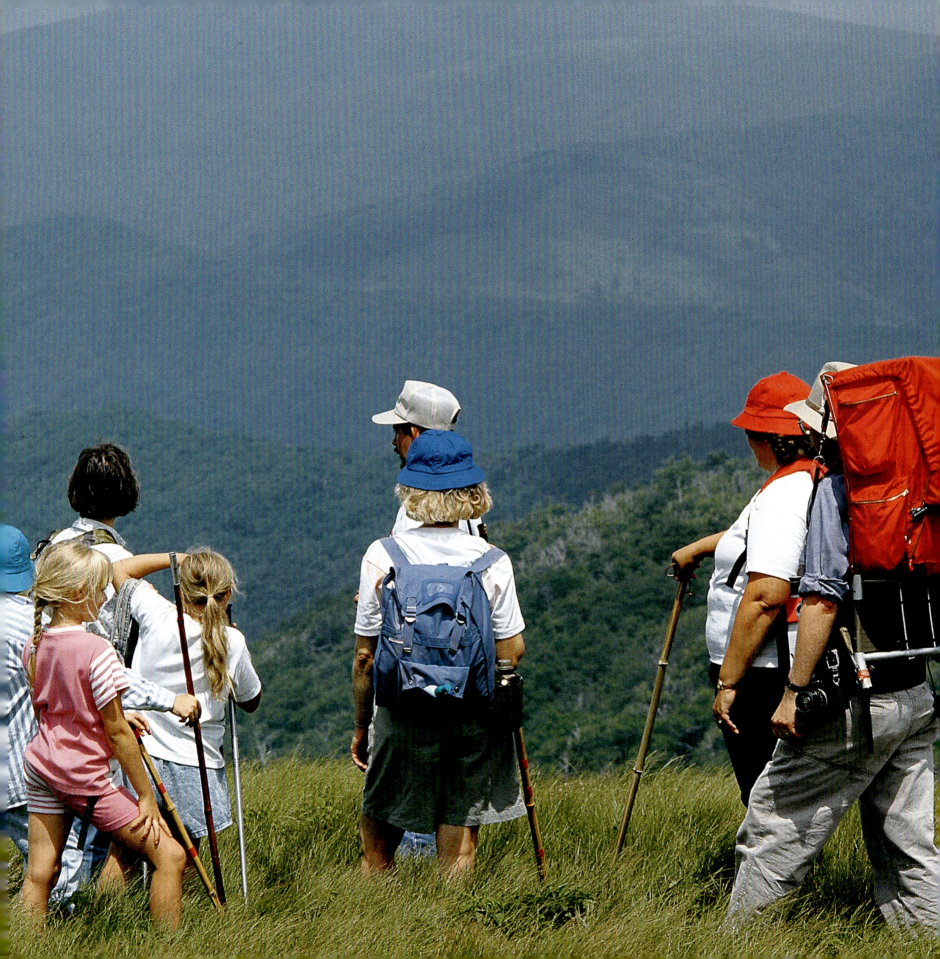

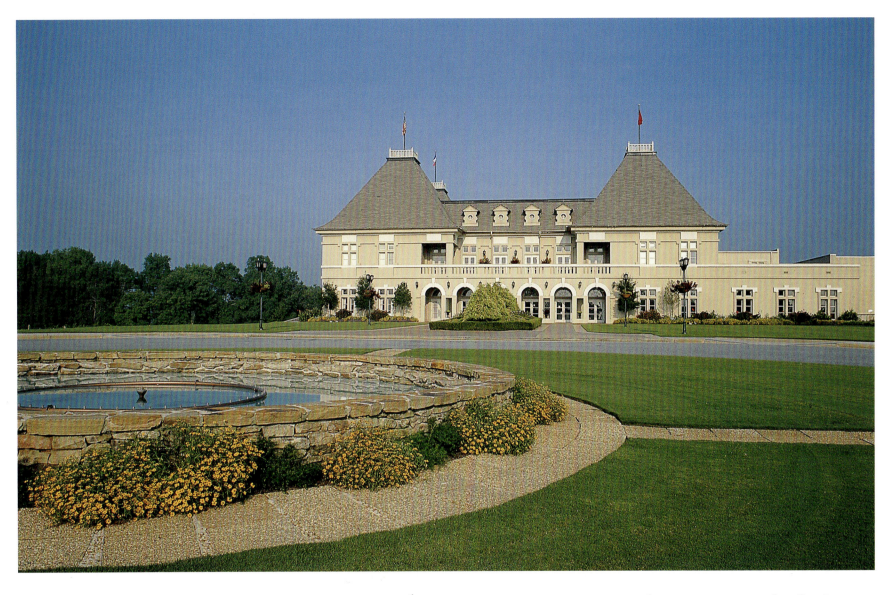

Château Élan Winery and Resort is situated 40 minutes north of Atlanta and modeled on the architecture and winemaking heritage of France. The owners added traditional Southern hospitality, a luxury inn, a spa, an equestrian center, and conference facilities to create a sumptuous retreat.

The Chattahoochee National Forest provides more than 430 miles of trails, ranging from short riverside ambles to rugged routes through the Blue Ridge Mountains. The world-famous Appalachian Trail winds for 79 miles through Georgia.

More than 35,000 soldiers lost their lives when Civil War forces clashed at Chickamauga in September, 1863. Fighting erupted again just two months later. For more than a century, Chickamauga-Chattanooga National Military Park—the oldest in the nation—has commemorated these events, some of the most violent battles in American history.

FACING PAGE—
The falls in Tullulah Gorge came to a sudden stop in the early 1900s, when the water that had carved the 1,000-foot canyon was dammed for hydroelectric power. After decades of lobbying by environmental groups, the land was returned to the state of Georgia and waterfalls pour through the gorge once again.

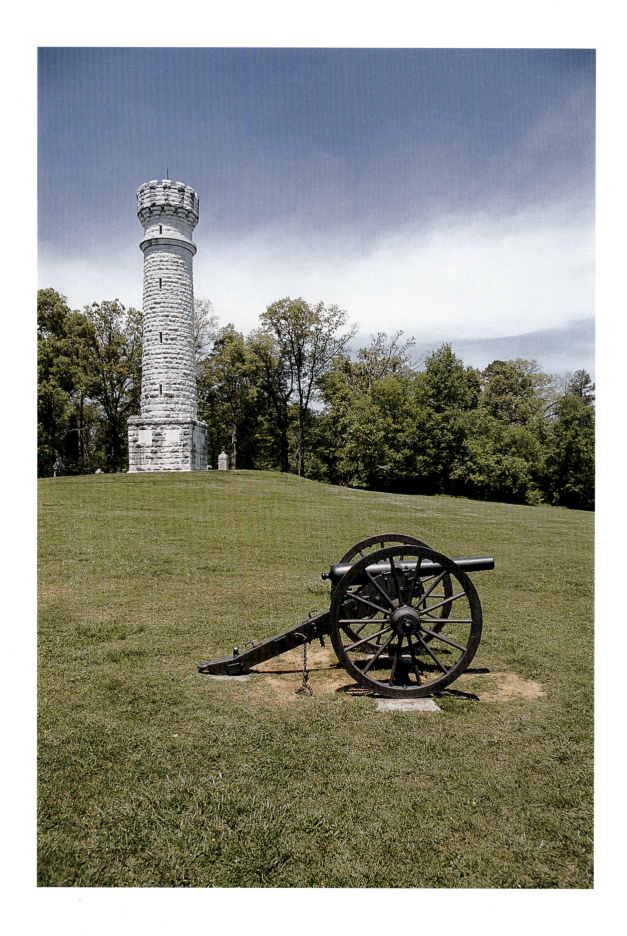

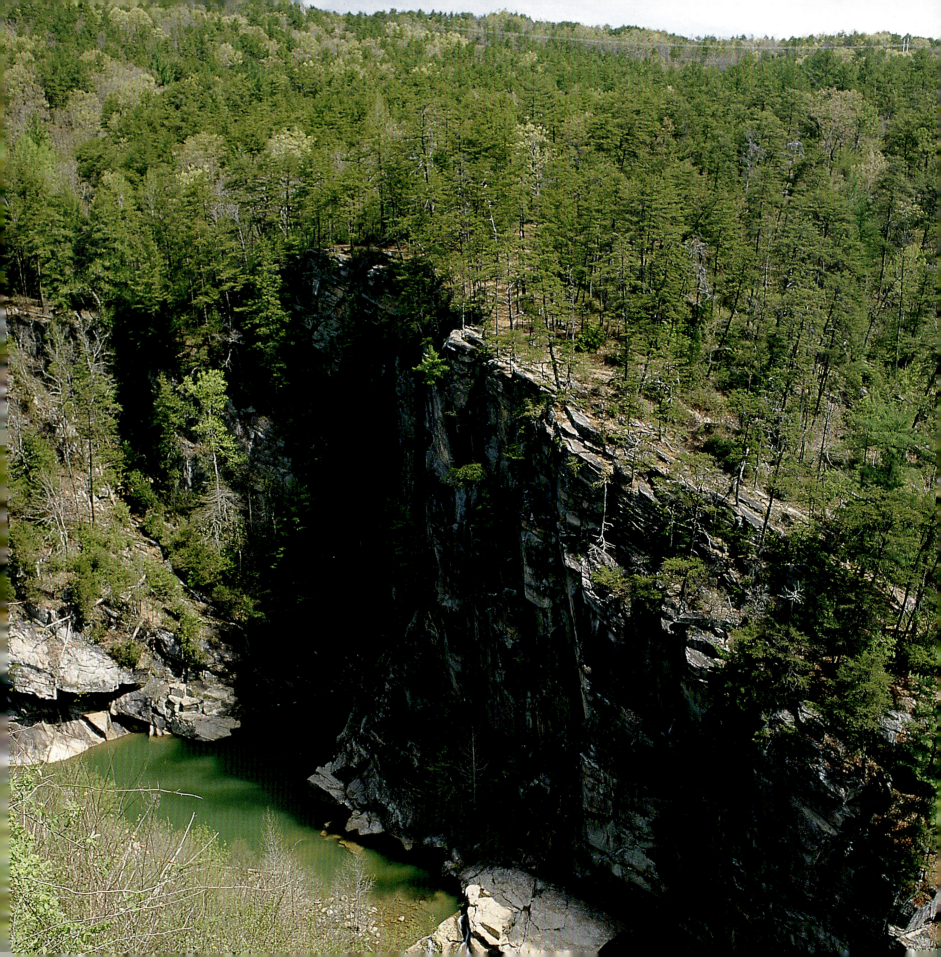

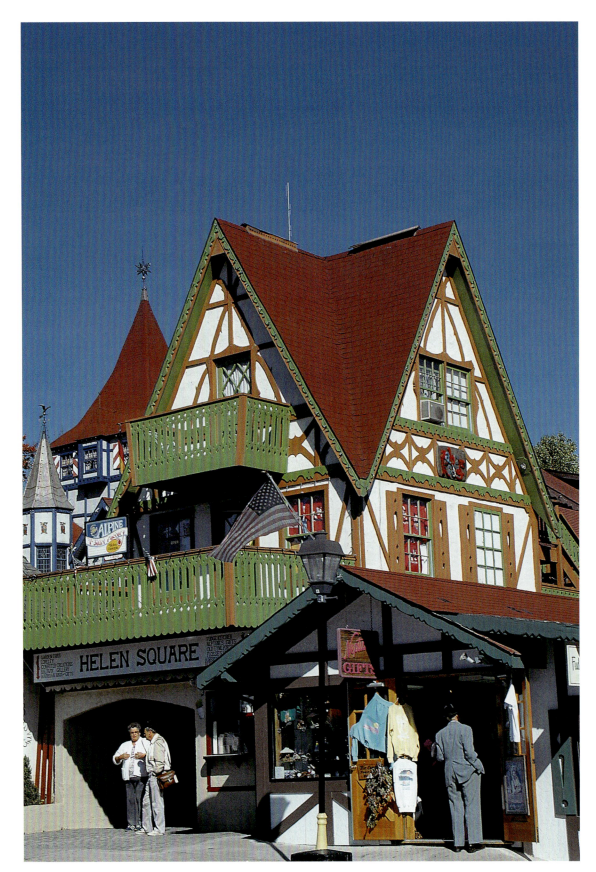

In the mid-1900s, tourists destined for the nearby mountains streamed past the tiny town of Helen. Local business leaders devised a plan to reinvent the community as a traditional Bavarian village with its own Oktoberfest. Tourism has boomed ever since.

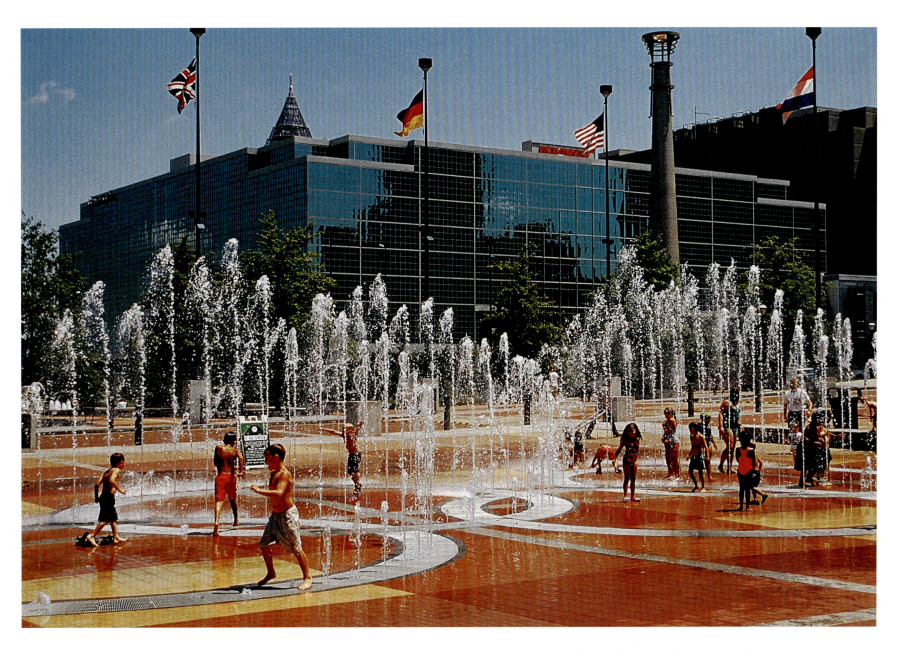

Billed as the world's gathering place during the 1996 Olympic Games in Atlanta, Centennial Olympic Park remains one of the event's most visible legacies. The Fountain of the Rings, a water feature designed in the shape of the Olympic logo, includes 251 water jets, 400 fog jets, and 487 lights.

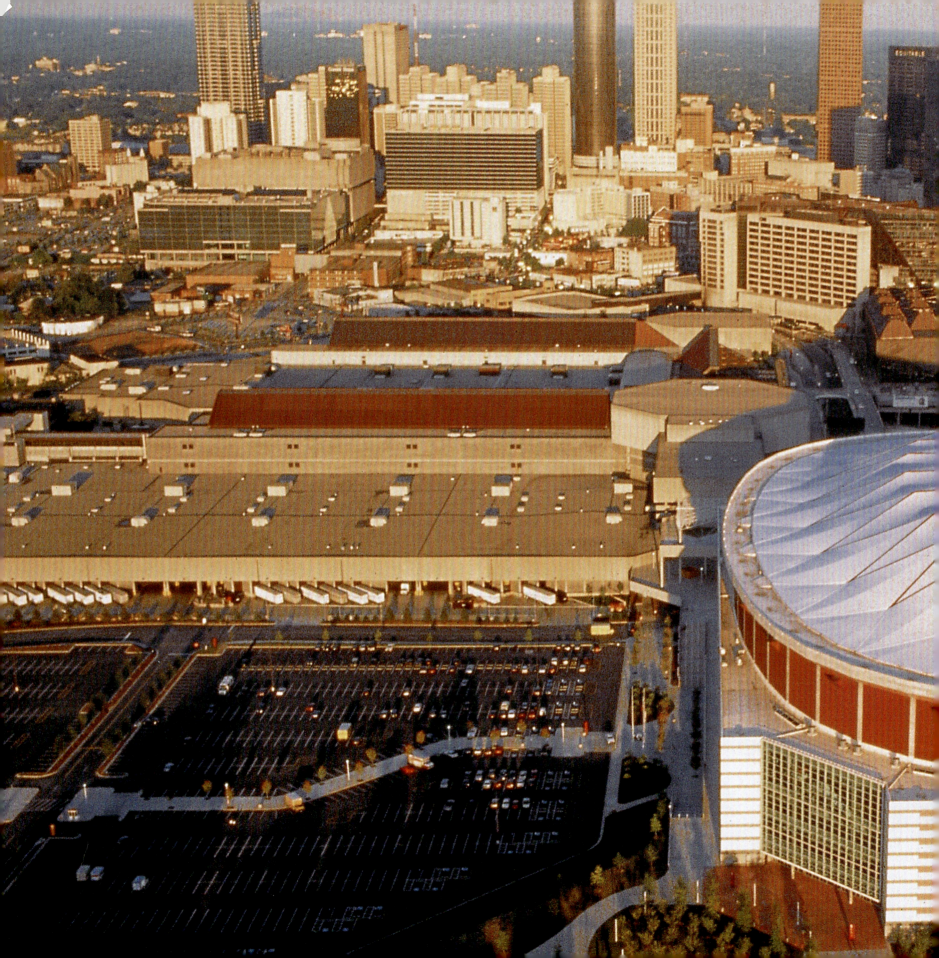

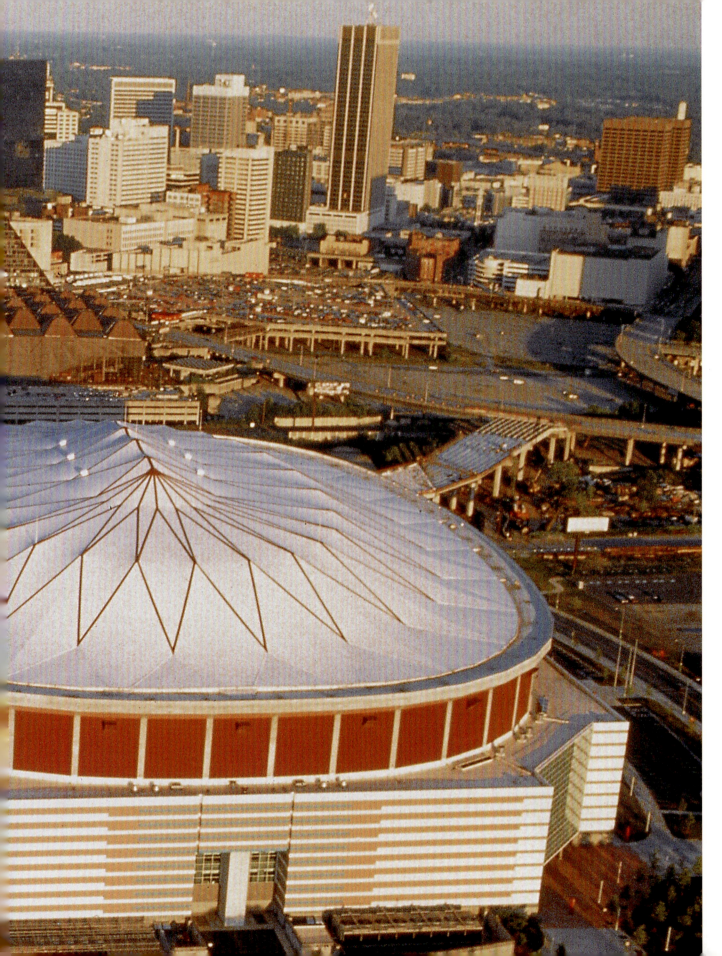

More than 70,000 people crowd the Georgia Dome, the largest cable-supported dome in the world, to see the Atlanta Falcons in action during football season. The center also hosts rock concerts, amateur sports tournaments, and conventions.

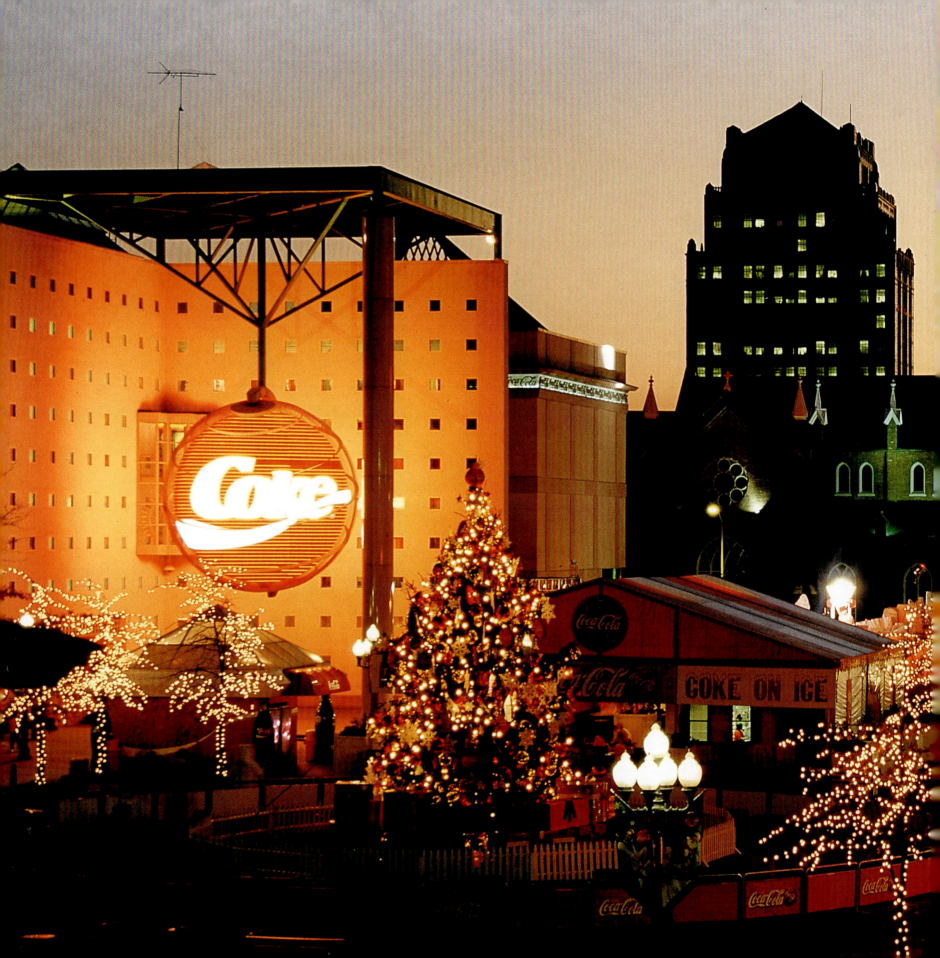

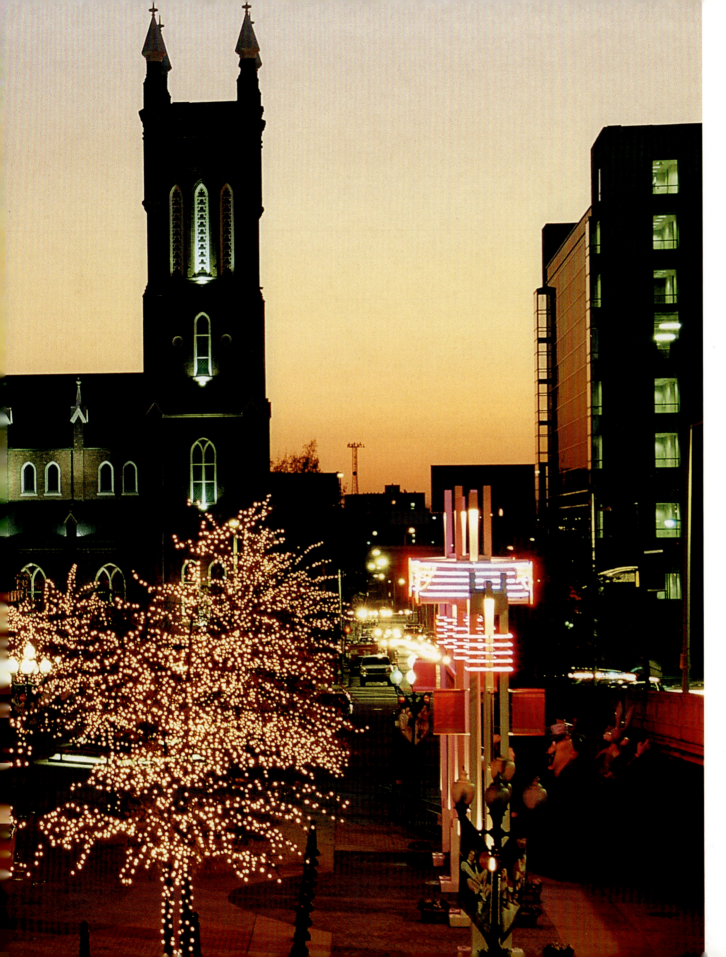

The corporate center of southwestern America, Atlanta is home to the head offices of Coca-Cola, UPS, Delta Air Lines, CNN, and many more of the nation's largest companies. The city was born at the southern terminus of the Western and Atlantic Railroad line in 1837 and incorporated 10 years later.

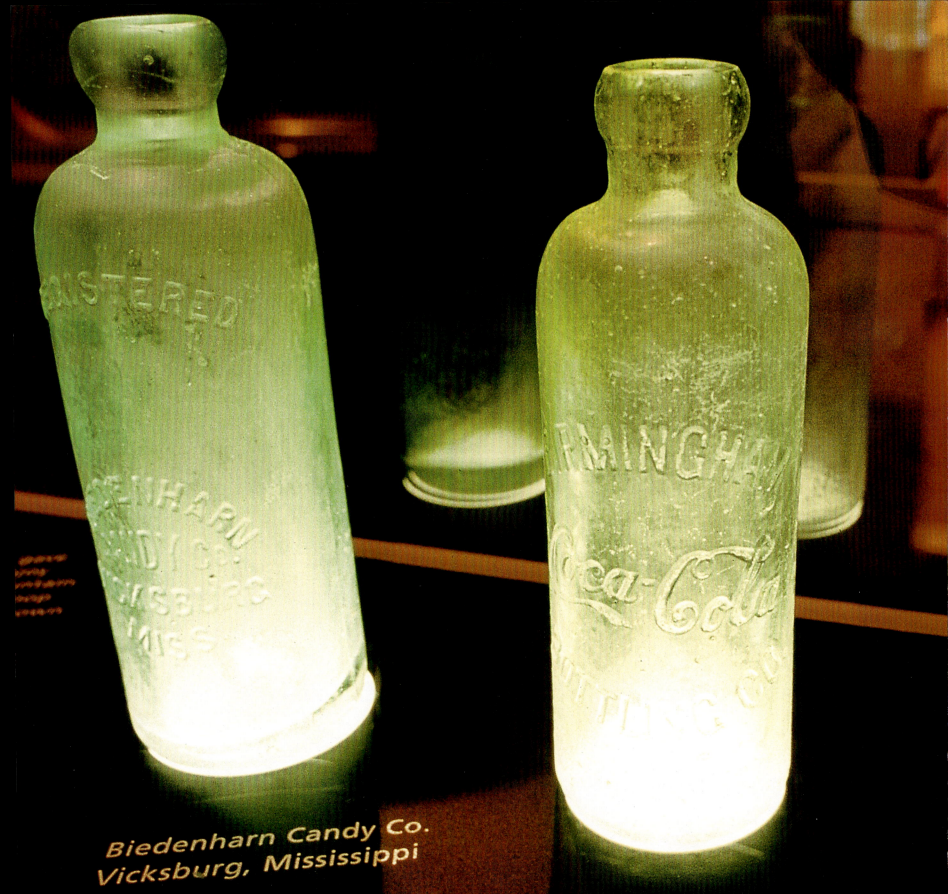

Biedenharn Candy Co.
Vicksburg, Mississippi

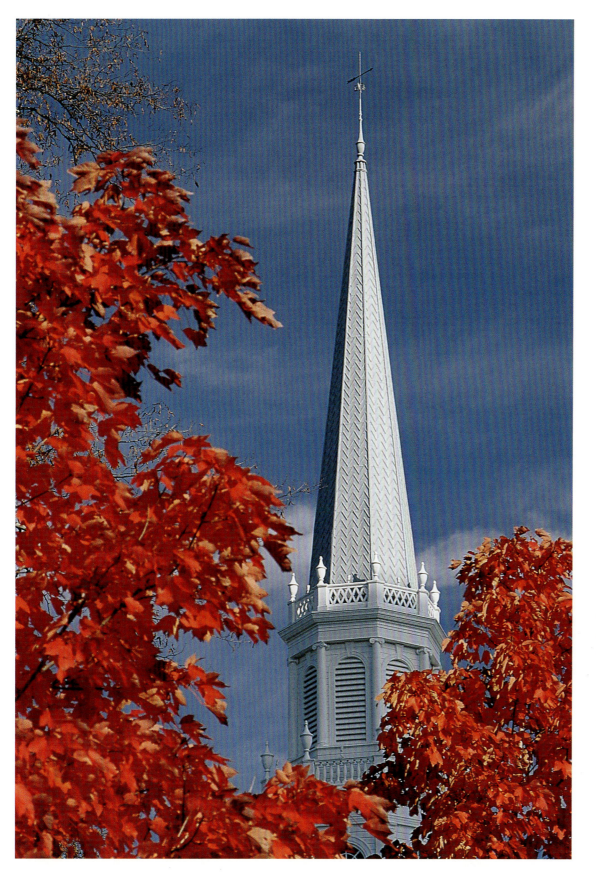

Second-Ponce de Leon Baptist Church was born in 1932, in the midst of the Depression, with the merger of two struggling congregations—Ponce de Leon Baptist Church and Second Baptist. The new parish thrived, and the grand sanctuary with its majestic steeple was completed in 1937.

FACING PAGE—
The World of Coca-Cola, a three-story pavilion in downtown Atlanta, celebrates the soft drink's century-long journey from a single pharmacy soda counter to store shelves in 200 nations. More than a billion Cokes are served around the world each day.

Georgia's State Capitol was an architectural wonder when it was built in the 1880s. It was one of the first public buildings in America to have elevators and central heating. The walls and floors are made of Georgia marble, and more than 100 ounces of gold shines from the 75-foot-diameter dome.

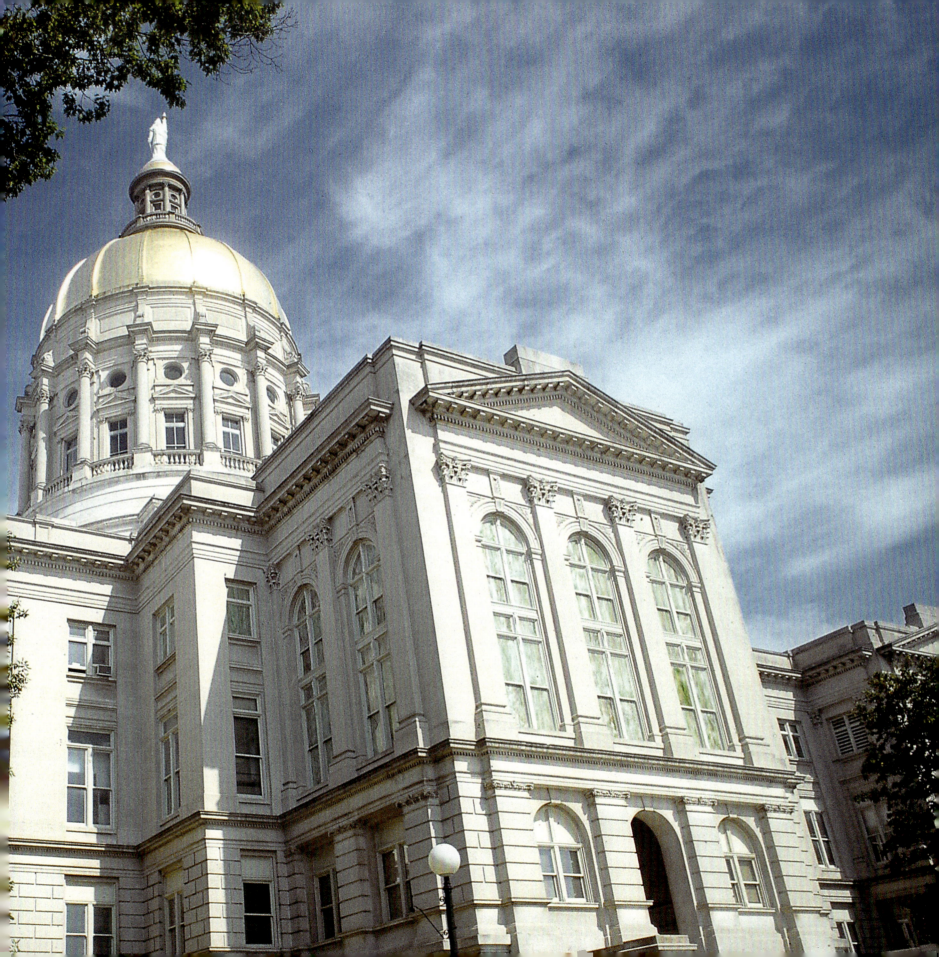

Set in Peace Plaza at Martin Luther King, Jr., National Historic Site, the *Behold* monument by sculptor Patrick Morelli celebrates the life of the civil rights leader. Morelli chose a pose inspired by an ancient African tradition of holding newborns toward the sun, that they might behold a power greater than themselves.

FACING PAGE—
Margaret Mitchell rented a suite in this small Atlanta apartment building between 1925 and 1932, dedicating herself to the creation of *Gone With the Wind*. The two-story building is now a museum, which houses movie set memorabilia and artifacts from Mitchell's life.

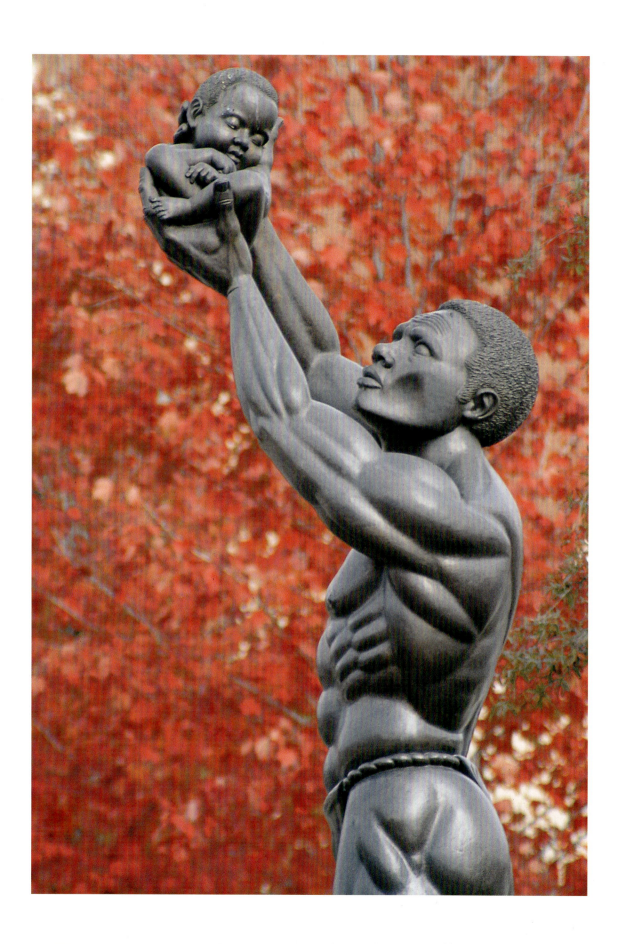

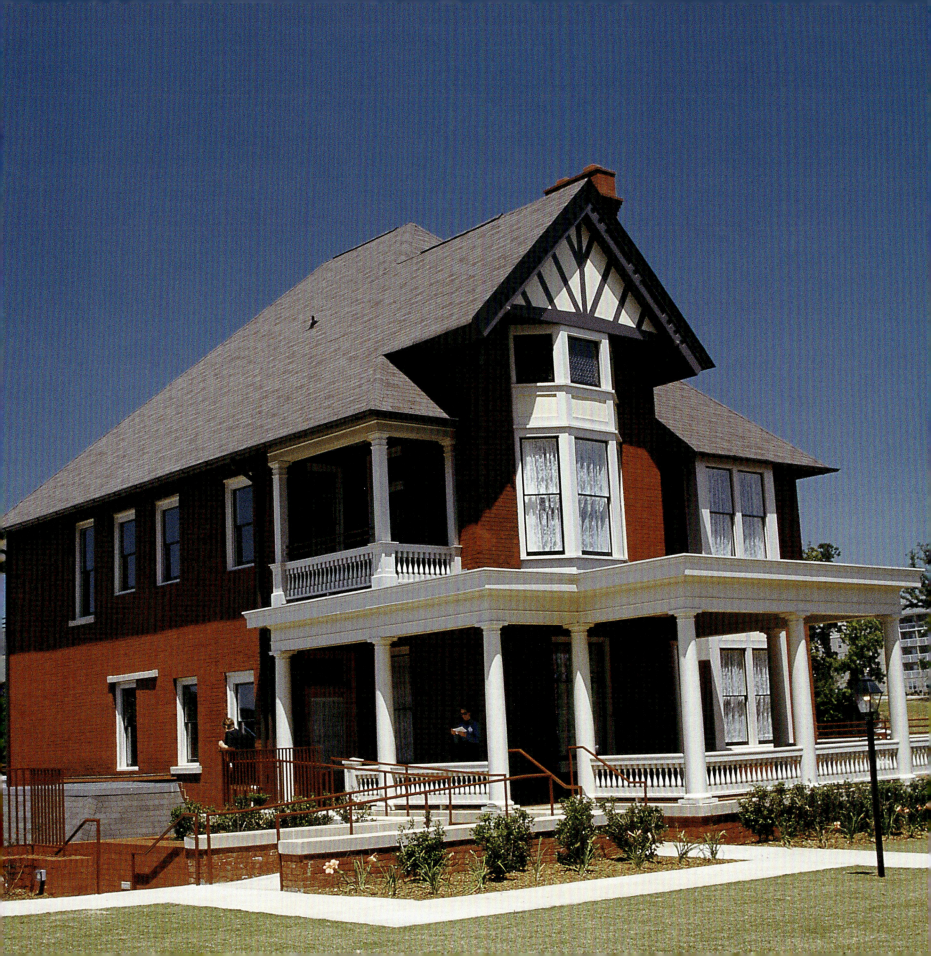

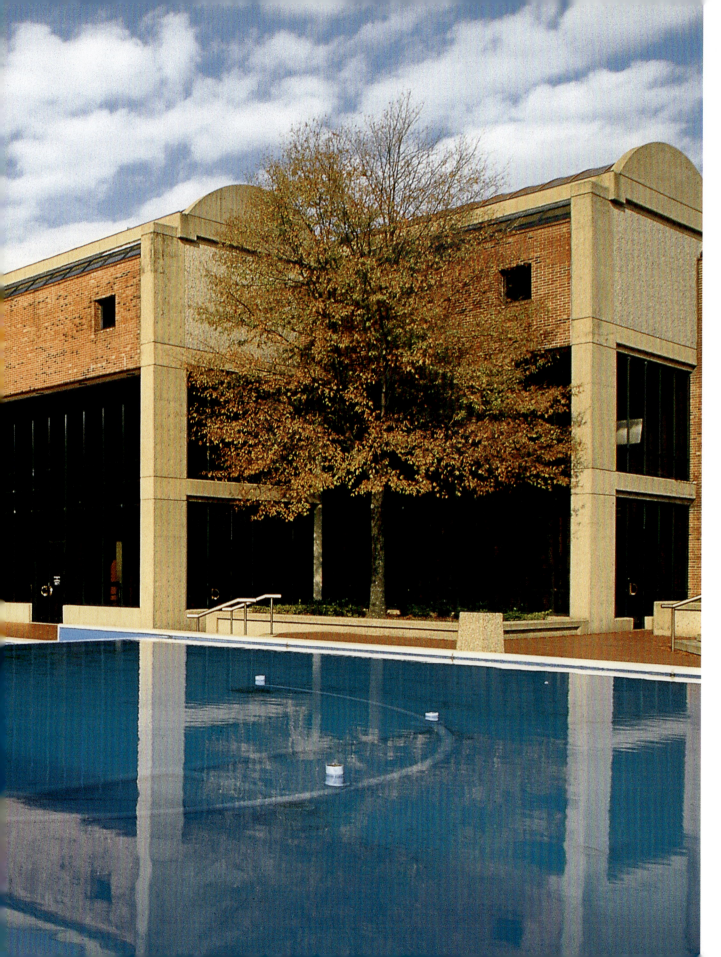

Atlanta native Martin Luther King, Jr., was born in 1929. Known for his eloquent oratory and passionate beliefs, King was a leader in the American civil rights movement and won the Nobel Peace Prize in 1964. He was assassinated on April 4, 1968. Martin Luther King, Jr., National Historic Site was established 12 years later to honor his achievements.

Peidmont Park is transformed for the Atlanta Dogwood Festival each April. More than 50 local performers and international stars dominate three outdoor stages. Nearby, crowds wander through an artists' market and an international food fair.

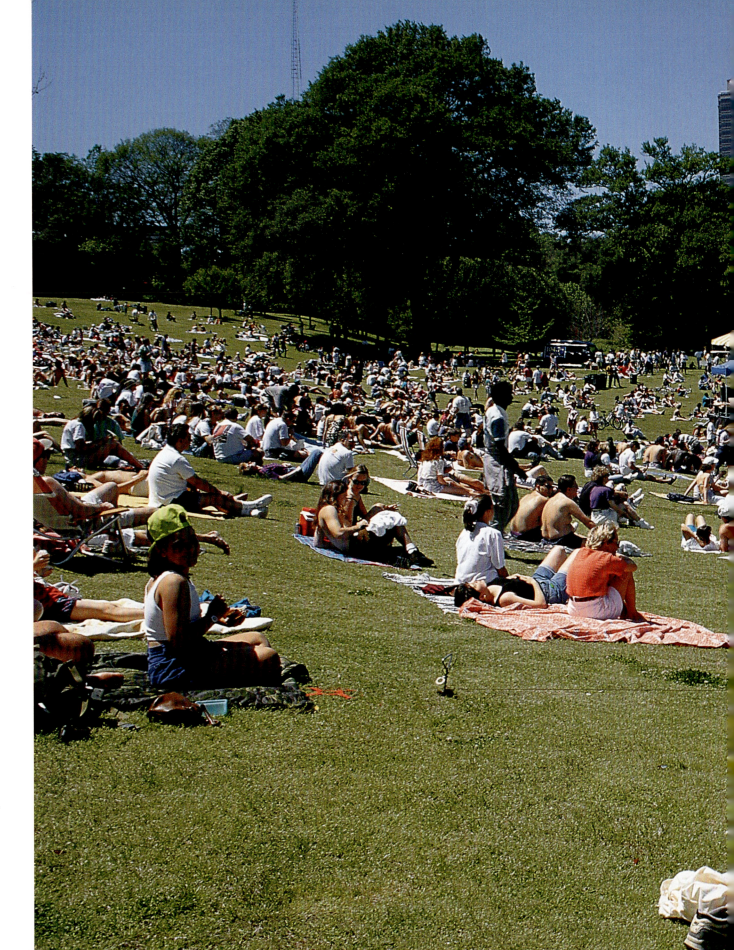

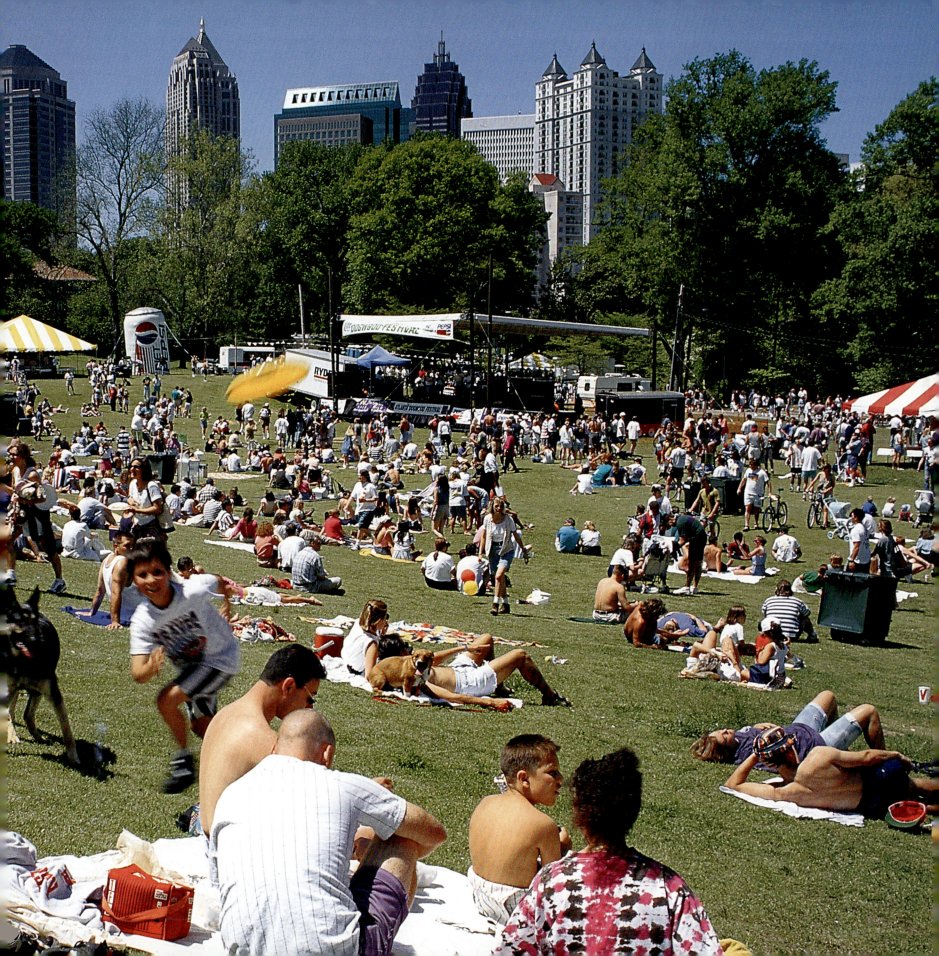

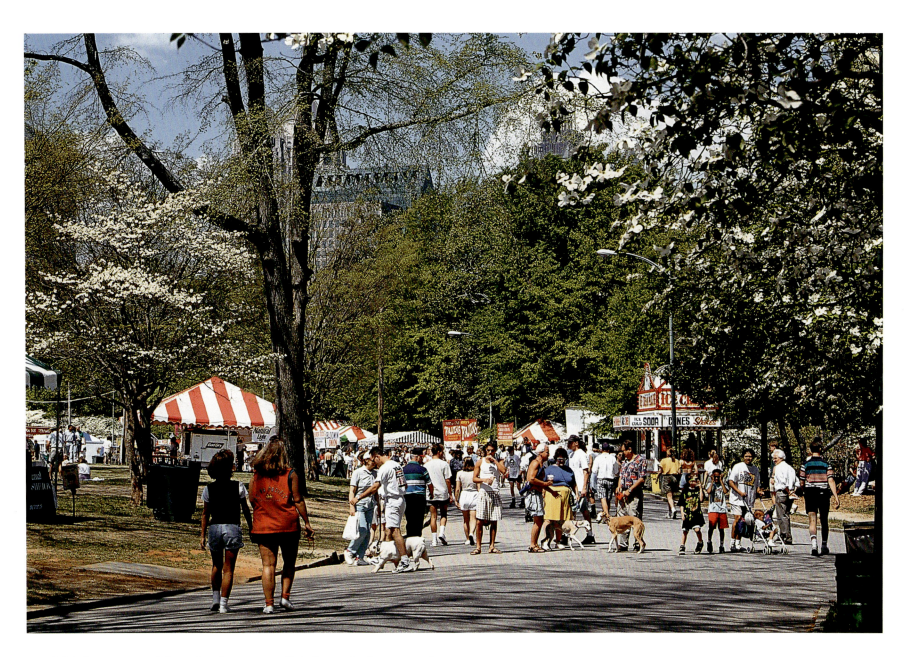

In 1936, inspired by the beauty of Atlanta's dogwood trees, department-store owner Walter Rich founded the Atlanta Dogwood Festival. His vision of a springtime pilgrimage to Atlanta has been realized every year since.

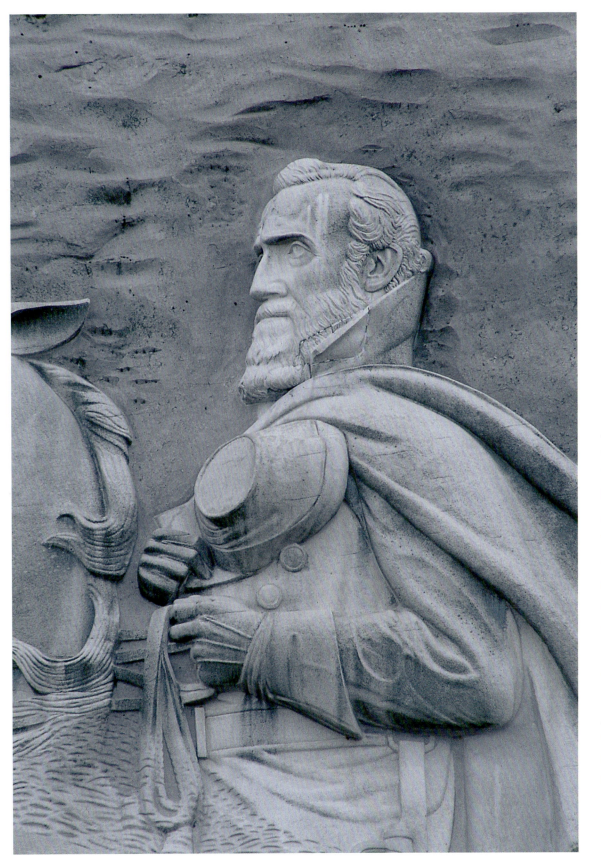

Just 16 miles from downtown Atlanta, Stone Mountain Park is named for a massive uprising of bare granite. Here, over a period of more than 50 years, sculptors carved a relief of President Jefferson Davis, General Robert E. Lee, and General Thomas J. "Stonewall" Jackson. Completed in 1972, the relief is larger than a football field.

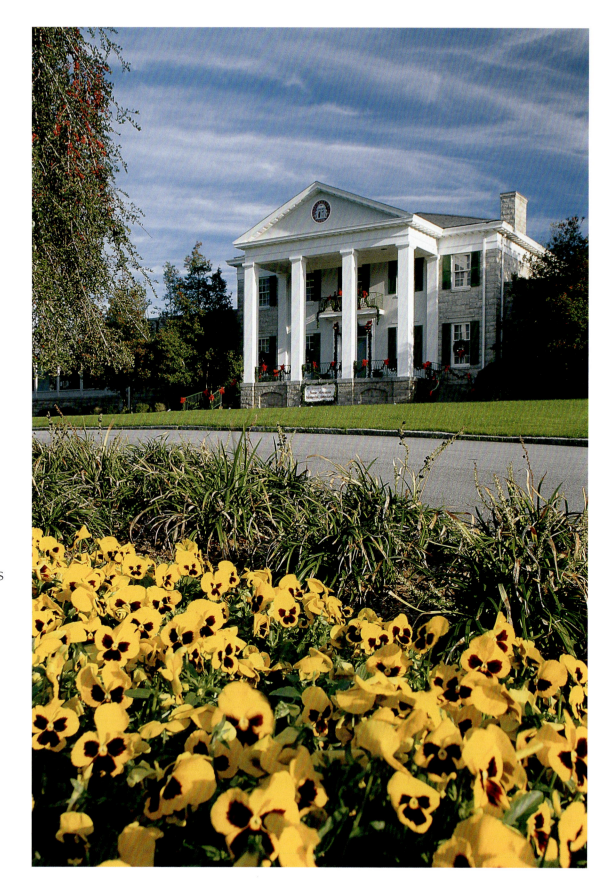

More than 4 million visitors tour Stone Mountain Park each year, both to view the historic attractions and to explore the park's 3,200 acres. Nature trails wind past serene lakes, and woodlands harbor red-tailed hawks, great blue herons, box turtles, deer, and foxes.

Antebellum Plantation at Stone Mountain Park allows tourists to explore an early nineteenth-century settlement. The plantation's authentic buildings include a manor house, a coach house, a plantation office, a smokehouse, and slave cabins, all rescued from sites across the state.

Macon prides itself on having more cherry blossoms than any other city in the world, making it a favorite with springtime travelers. Along with its natural attractions, Macon offers the Georgia Sports Hall of Fame, the Georgia Music Hall of Fame, and more than 5,500 historic buildings.

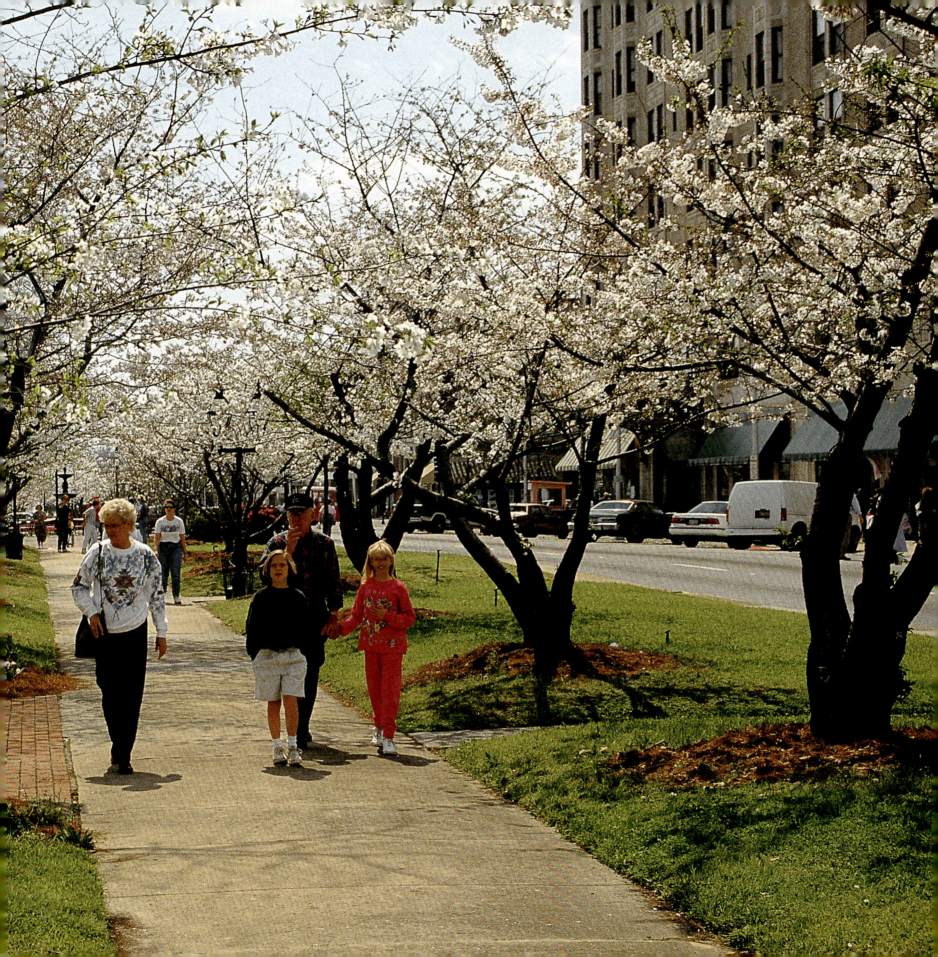

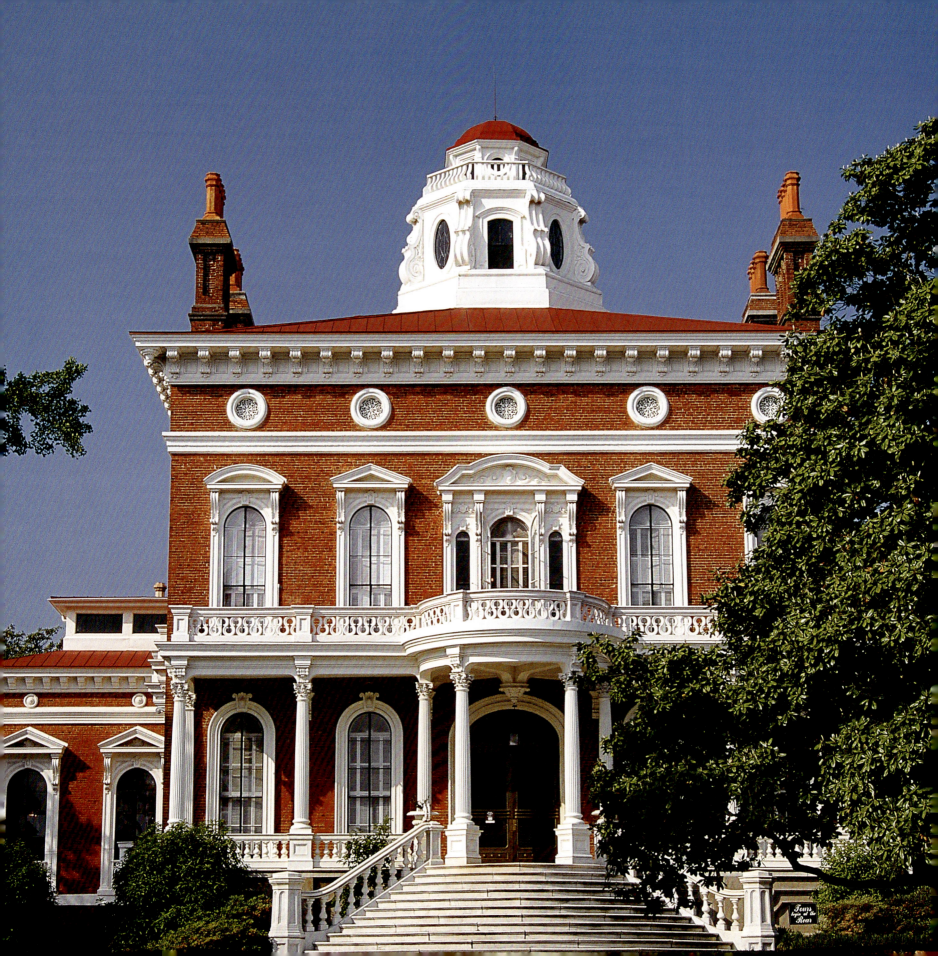

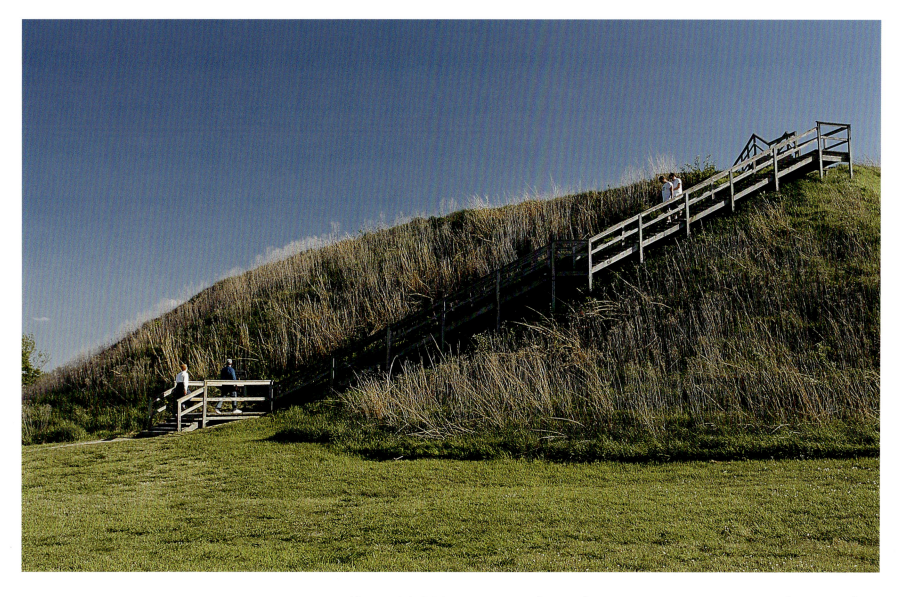

About 10,000 years ago, the prehistoric Mississippian people created a ceremonial lodge and giant earthen mounds near Macon. The purpose of the mounds is still a mystery, but visitors can search for clues at the 683-acre Ocmulgee National Monument.

Banking and railway baron William Butler Johnston commissioned this Macon mansion for his bride in 1859. His descendants sold the house to Parks Lee Hay. The 16,000-square-foot structure—now a museum and a national historic landmark—is known as Hay House.

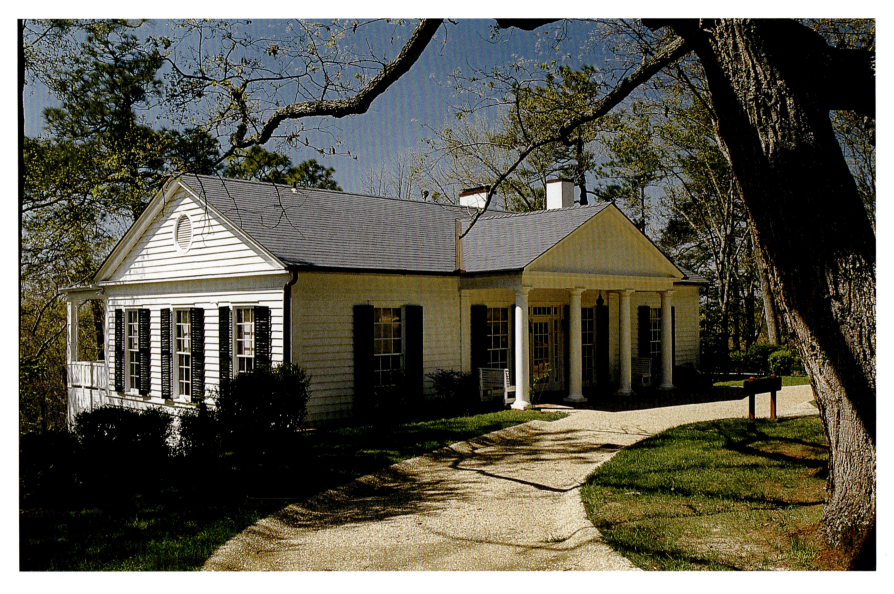

Franklin D. Roosevelt commissioned his Little White House in 1932, near the hot springs where he strengthened his polio-damaged legs. Now a historic site, the house hosts more than 100,000 visitors each year. The first polio vaccine was introduced a decade after Roosevelt's death.

Wandering the hiking trails of Georgia's largest state preserve, visitors might stumble upon the favorite picnic spot of Franklin D. Roosevelt. The land that is now F. D. Roosevelt State Park served as a retreat for the leader after he was diagnosed with polio in 1921.

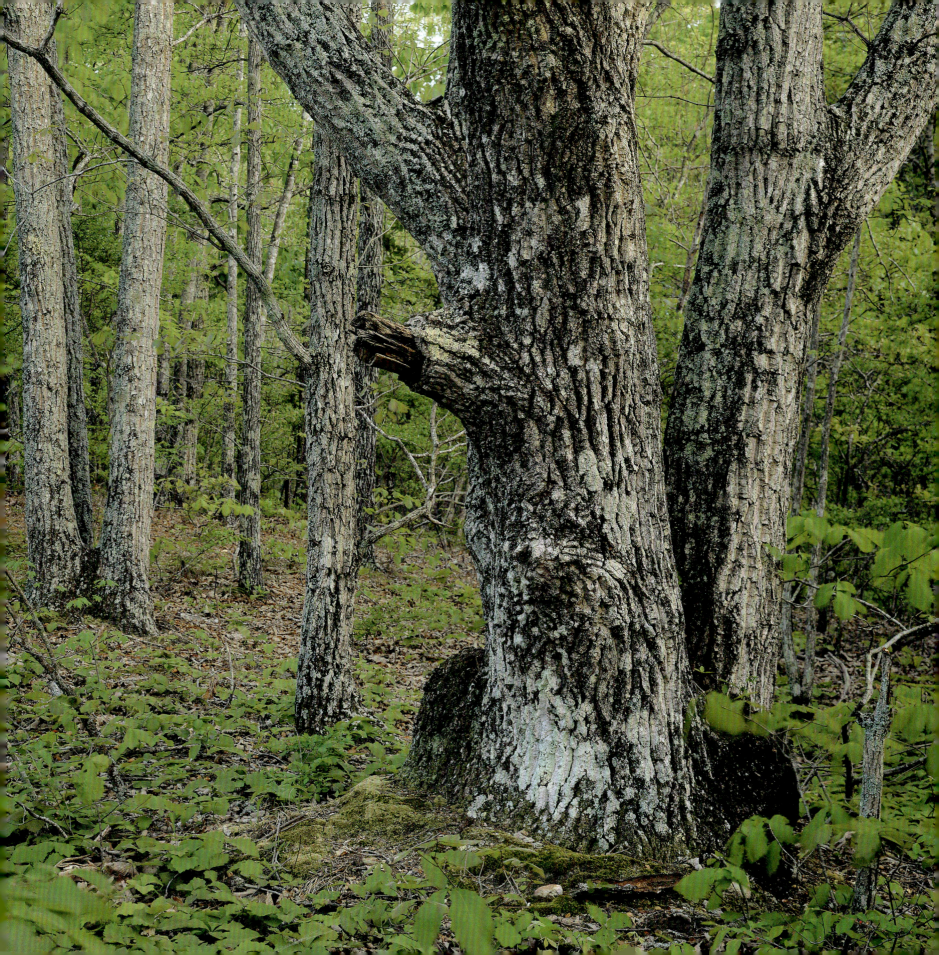

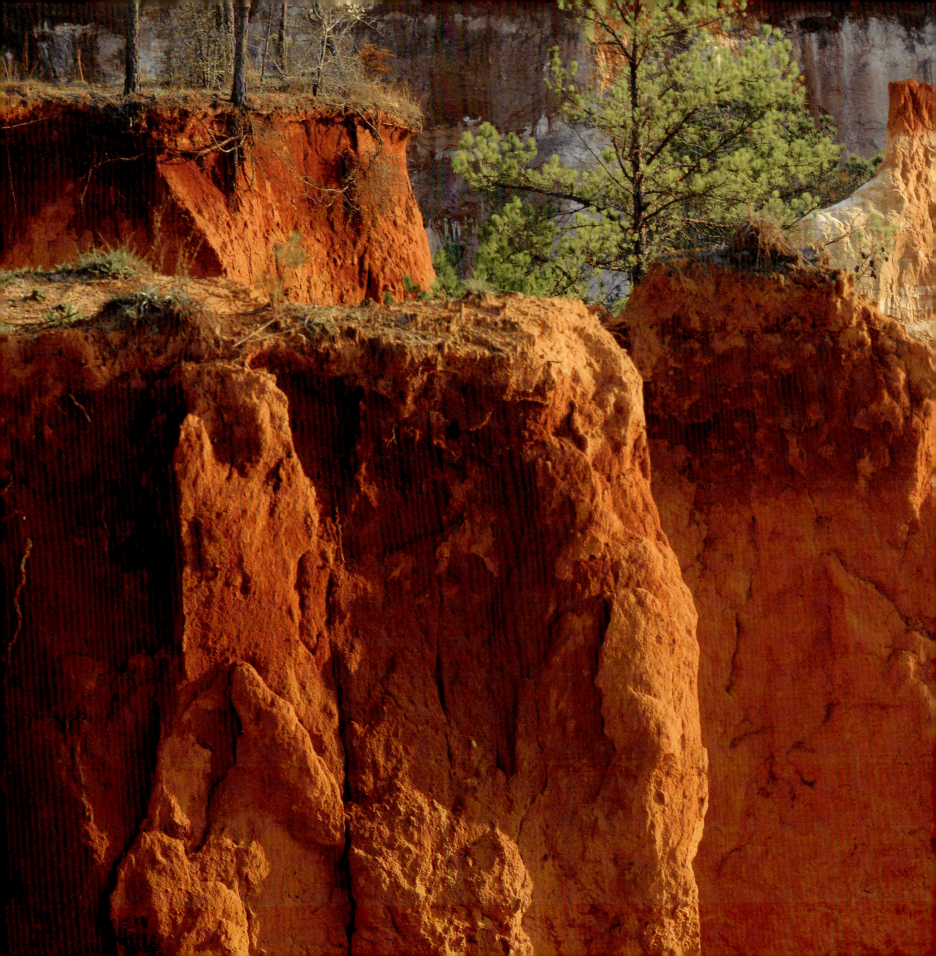

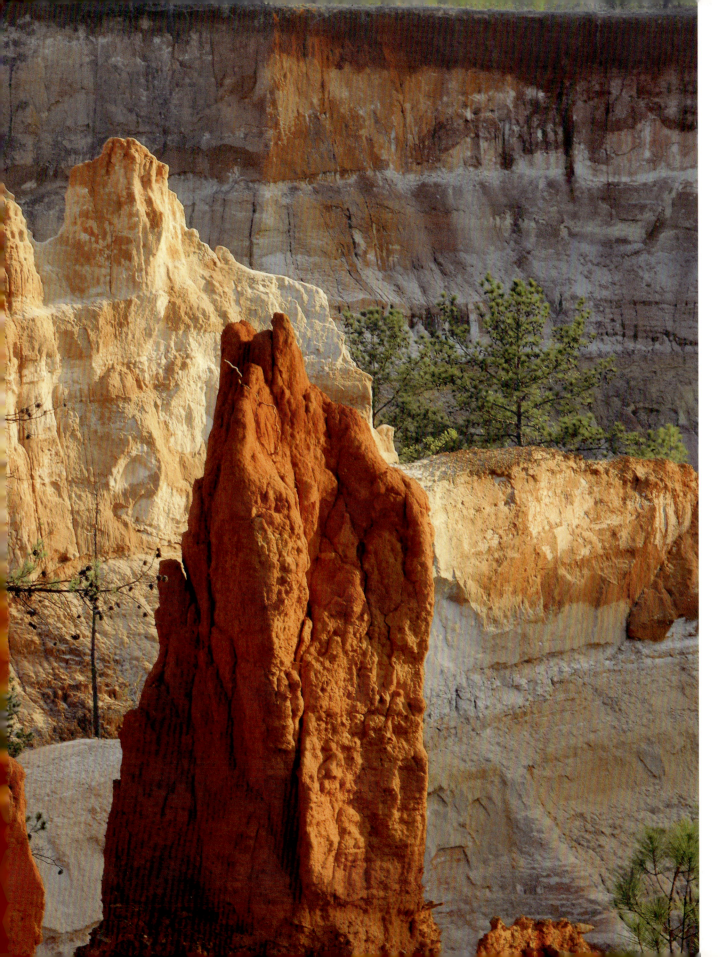

The land encompassed by Providence Canyon State Park was once forest. When settlers cleared the region for their homesteads less than two centuries ago, creeks eroded the loosened soil to form ditches, then gullies, and finally canyons. Some of the 16 gorges are more than 150 feet deep.

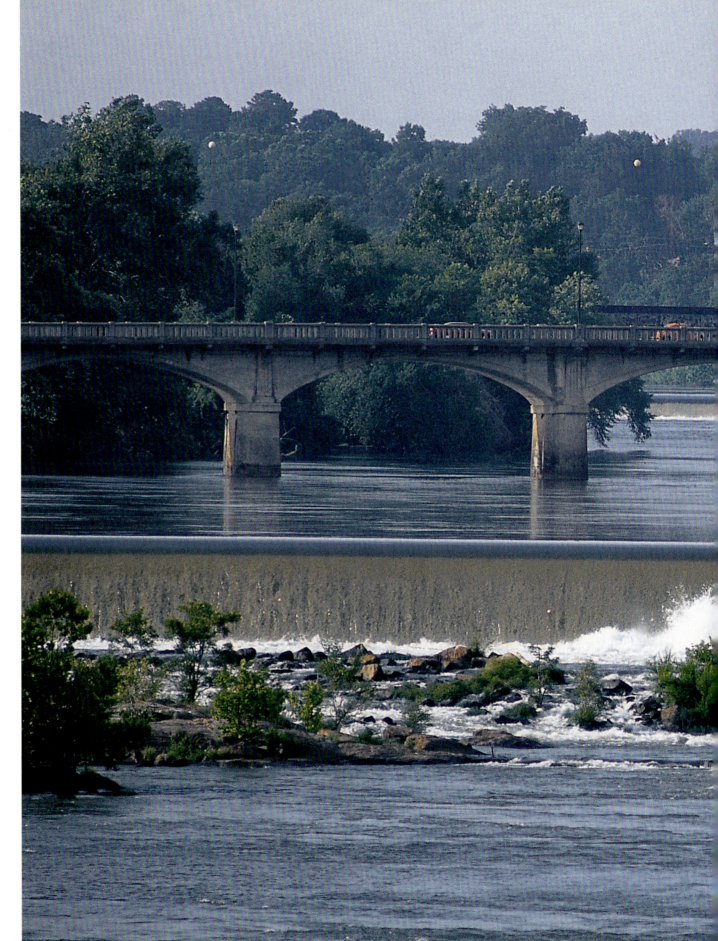

Columbus, at the eastern edge of Georgia, was founded in 1828. Here, cotton from the nearby plantations was loaded onto riverboats bound for the Gulf of Mexico. By the mid-1800s, this was one of the largest industrial centers in the south, home to cloth factories and ironworks.

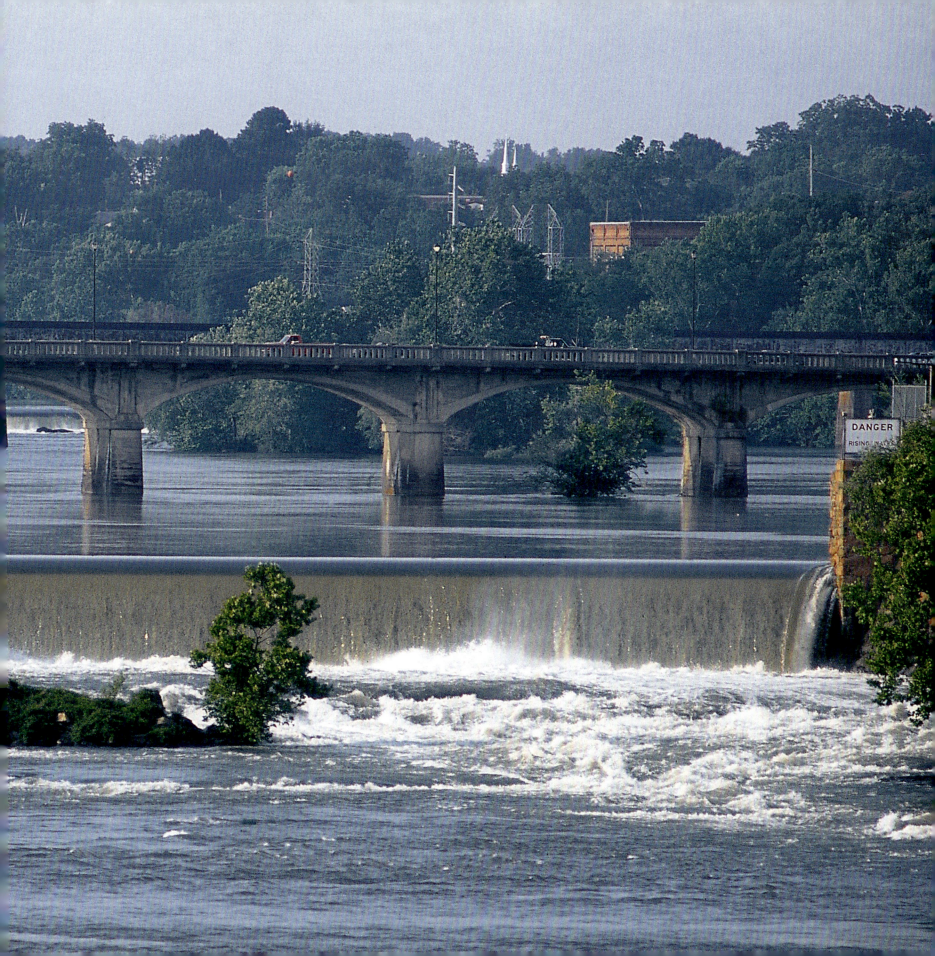

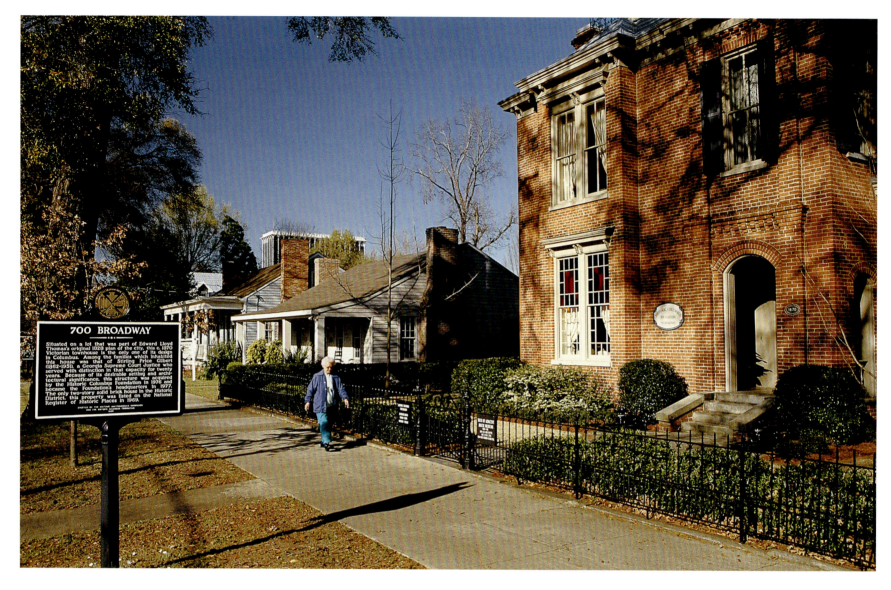

The Historic Columbus Foundation, housed in this restored villa, works to preserve the city's historic sites. These include the Riverfront Industrial District National Historic Site, the Springer Opera House, built in 1871, and the Folly, a home built in the shape of two octagons.

Five thousand years ago, the inhabitants of ancient Georgia created a mound in the shape of an eagle, 102 feet from beak to tail and with a 120-foot wingspan. Made entirely of quartz, the mound is 10 feet high. Though they believe it was a sacred site, archaeologists can't explain why the mound was created or how it was used.

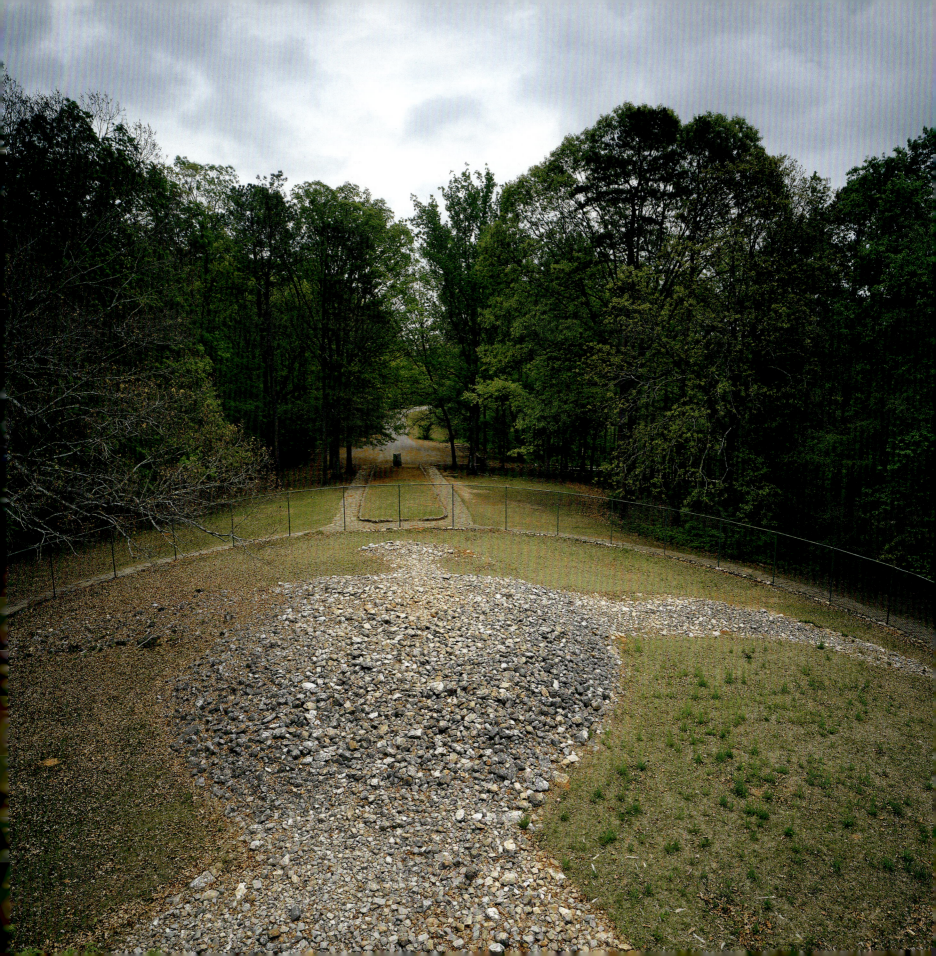

While PGA tour champions perfect their putts at Mountain View Golf Course, aspiring golfers practice on the nine holes of Sky View, just a few miles away. Callaway Gardens, a 14,000-acre resort in Pine Mountain, offers a total of 63 holes on four distinct courses.

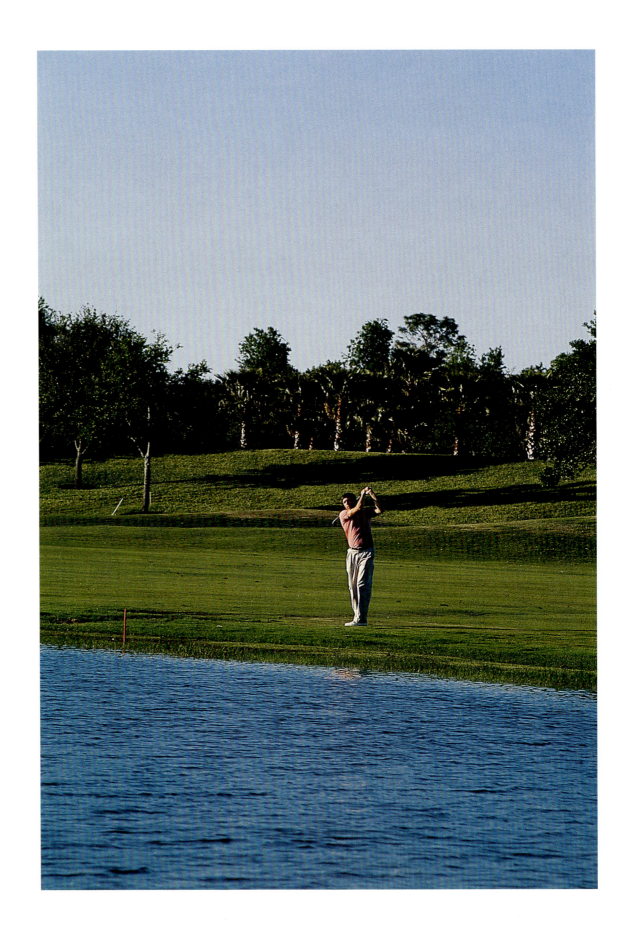

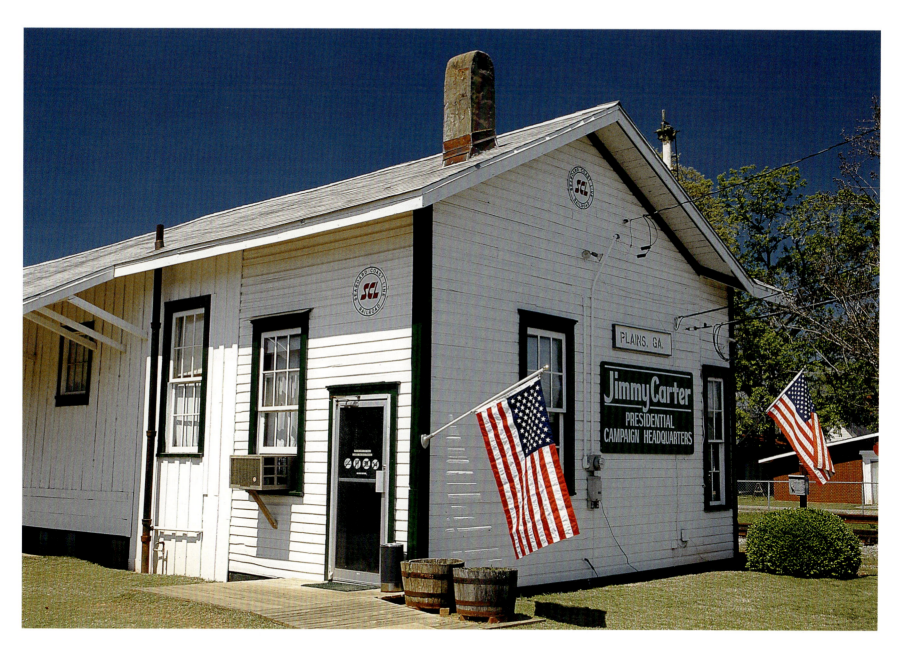

Jimmy Carter was born in Plains, Georgia, and returned to live here in 1981. The Jimmy Carter National Historic Site preserves the thirty-ninth president's home and school, along with the railway station that served as his 1976 election headquarters.

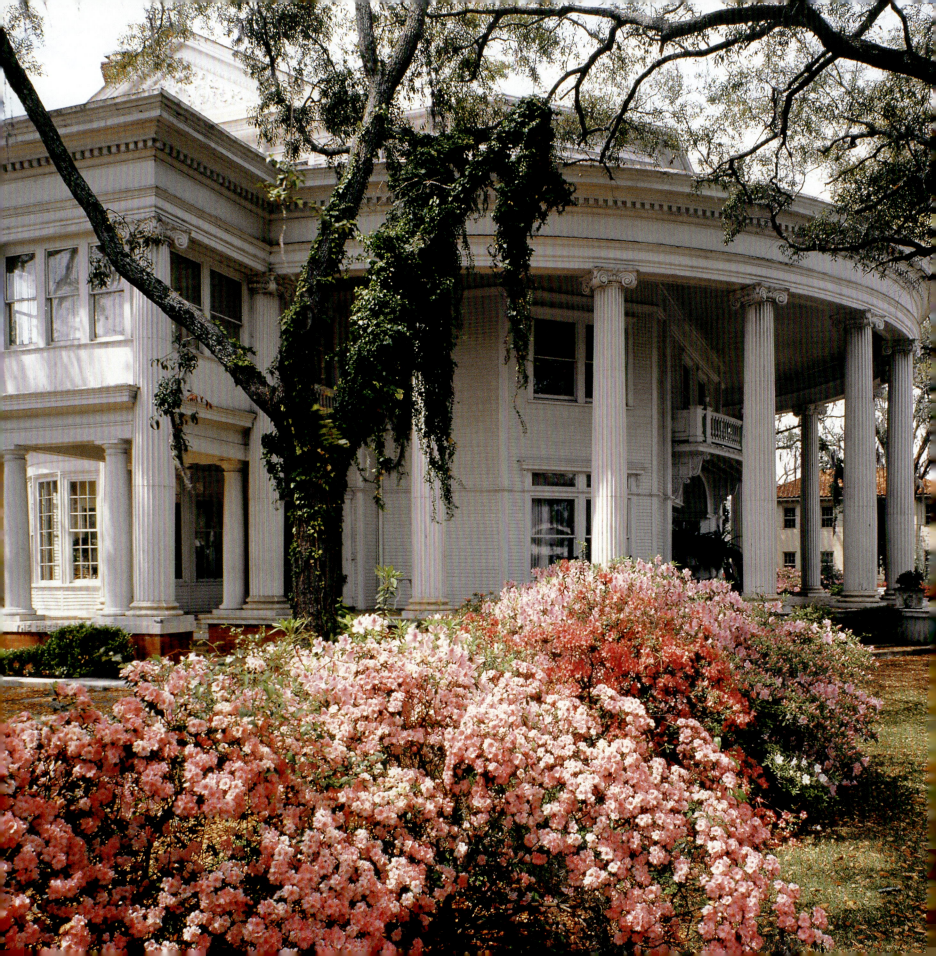

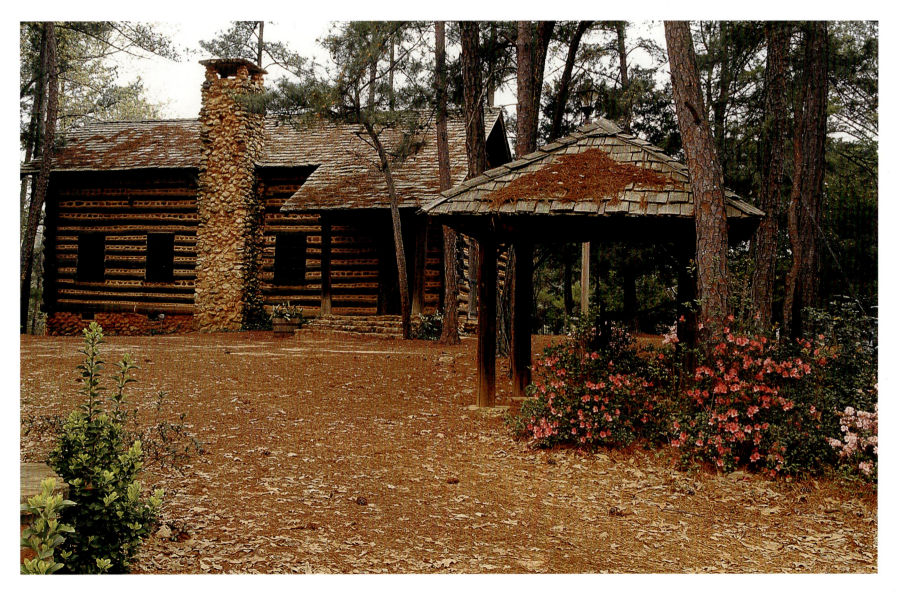

A village of about 20 people when the Civil War erupted, Andersonville was chosen by Confederate Captain W. Sidney Winder as the ideal site to hold prisoners of war. Crowding and unsanitary conditions led to 12,912 deaths before the war's end.

Nestled partway between Atlanta, Georgia, and Orlando, Florida, the city of Valdosta serves as a commercial center for the surrounding farmland. This gracious antebellum mansion, known as The Crescent, is the community's best-known landmark and is open to the public.

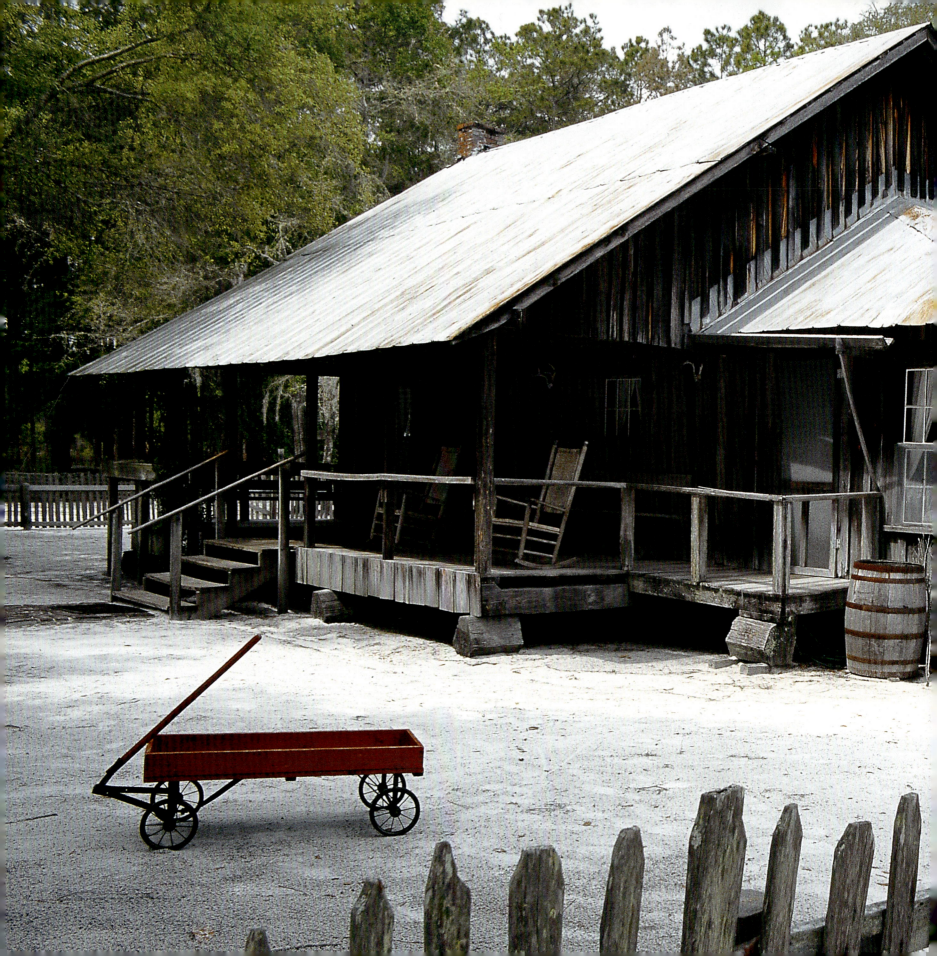

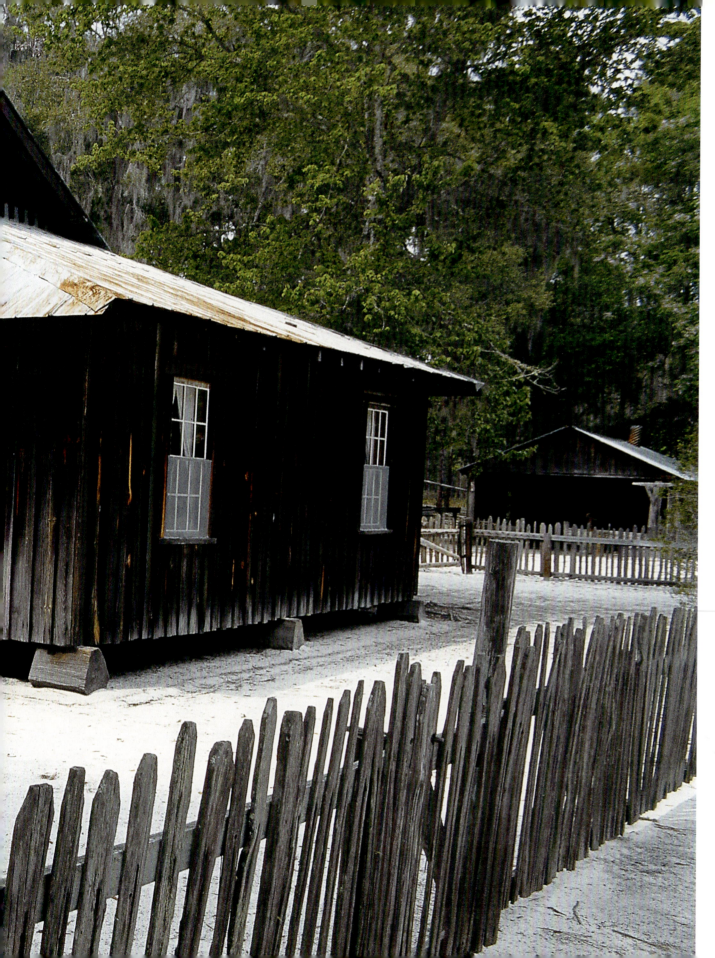

Home to rare reptiles, mammals, and raptors, Okefenokee National Wildlife Refuge encompasses a 430,000-acre swamp, the wetland reeds hiding a rich base of peat. The porous earth often shifts when stepped on, which is why local native people named the region Okefenokee, or "trembling earth."

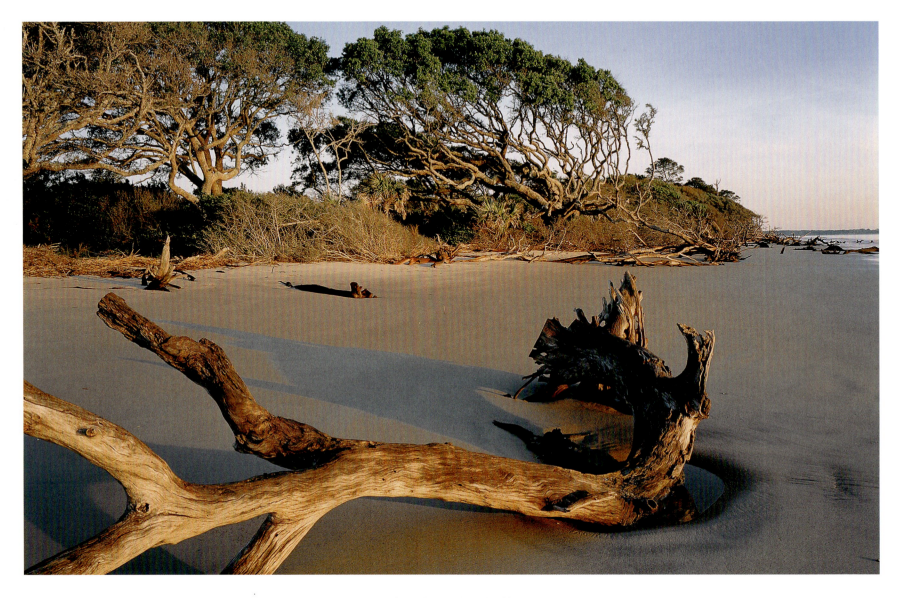

St. Simons Island, Sea Island, Little St. Simons Island, and Jekyll Island are called the Golden Isles, named by Spanish explorers who claimed them in the 1500s. Before the British took ownership in the 1700s, the islands spawned legends of pirates and shipwrecks.

Crooked River State Park is home to a historic grist mill, but it's best known as a family vacation destination. Sandy swimming holes beckon, while a boat ramp makes early morning fishing tempting. Picnic shelters and campsites dot the park.

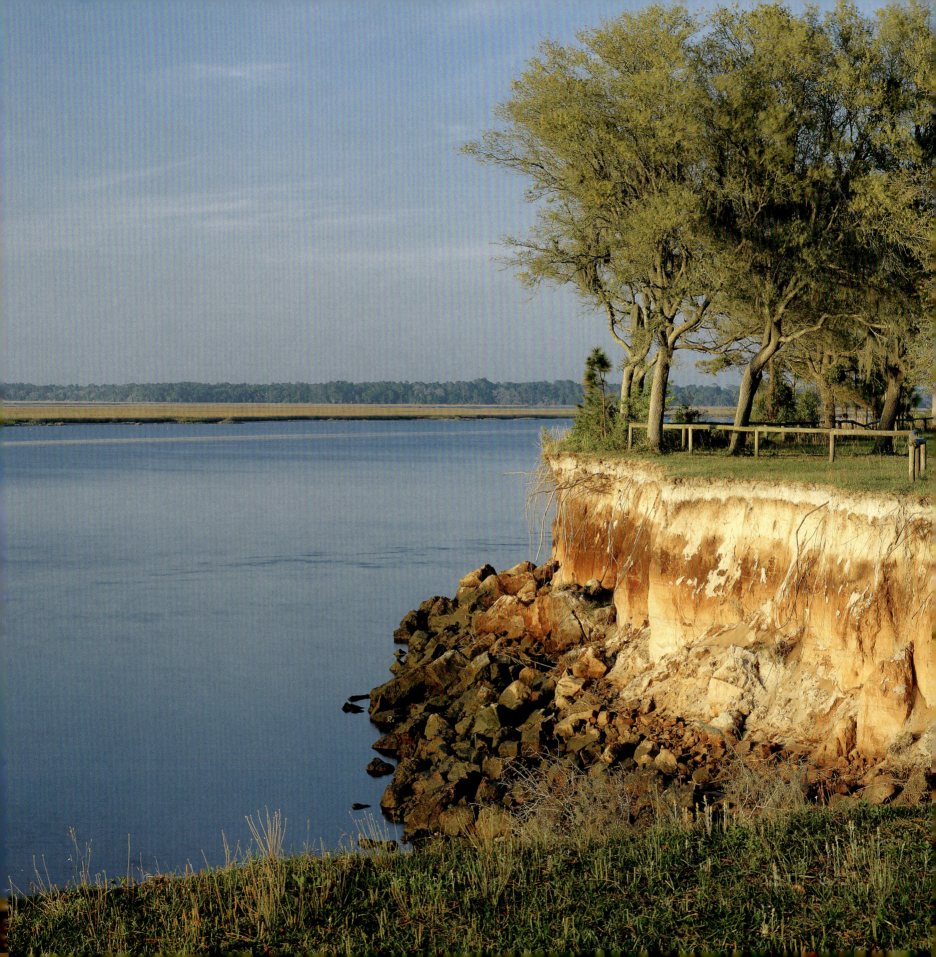

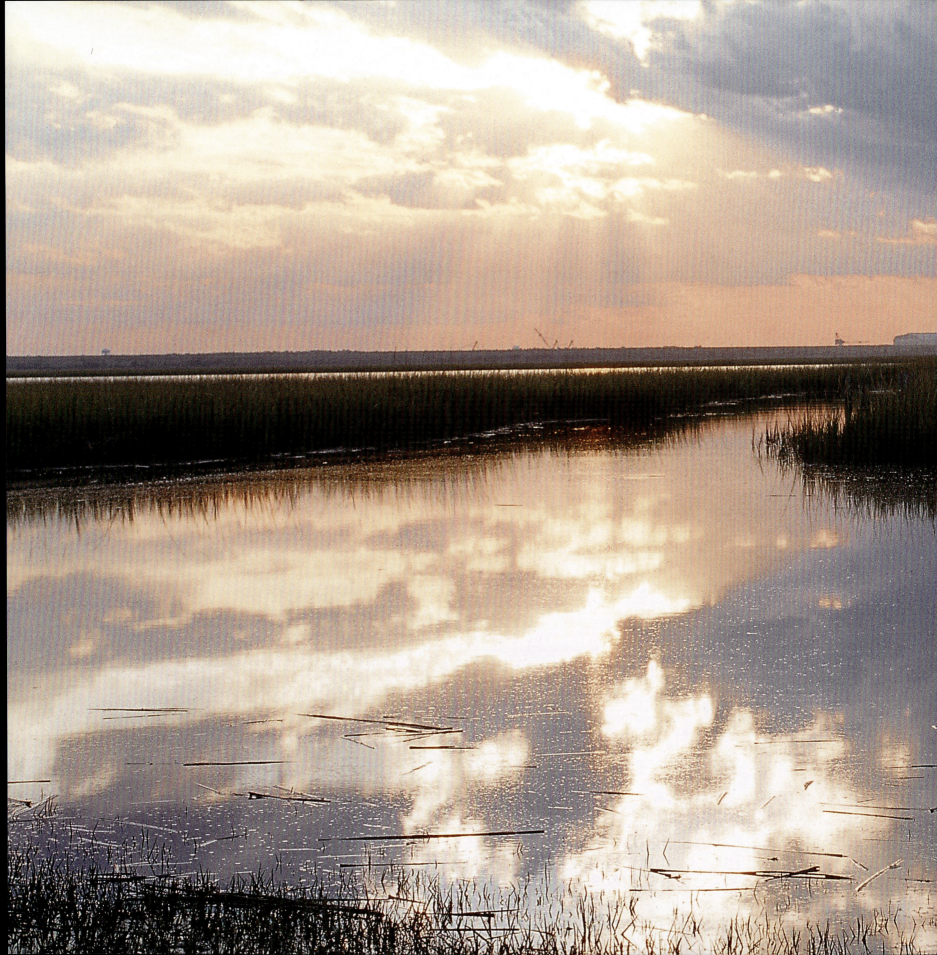

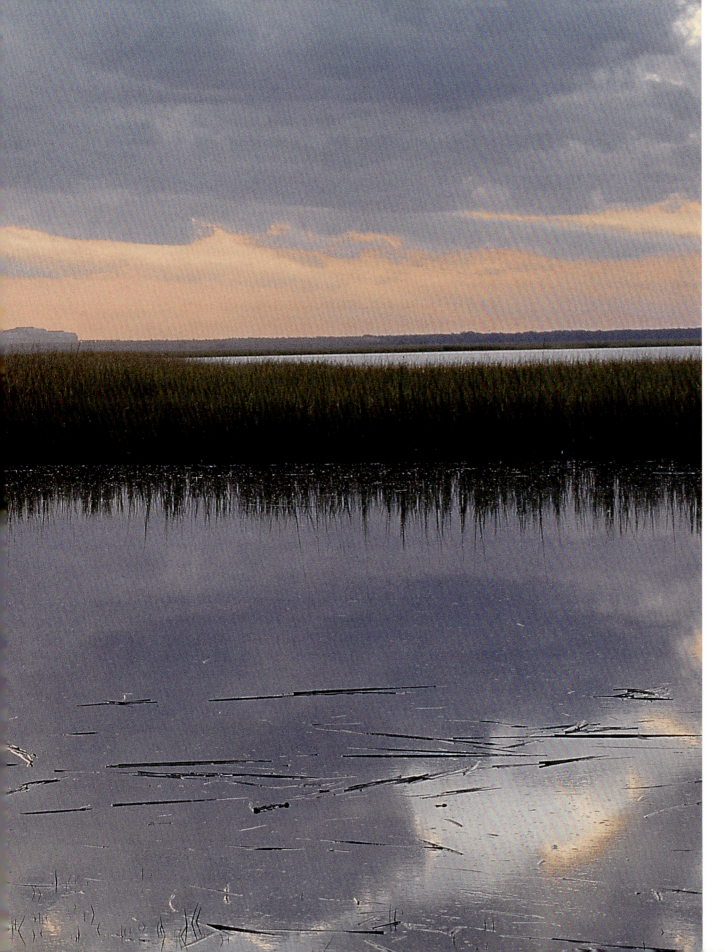

On Georgia's largest barrier island, Cumberland Island National Seashore protects 17 miles of white sand beaches. Here, rare loggerhead turtles lay their eggs, sand dunes shift with the winds, and wild horses graze on scrub grass.

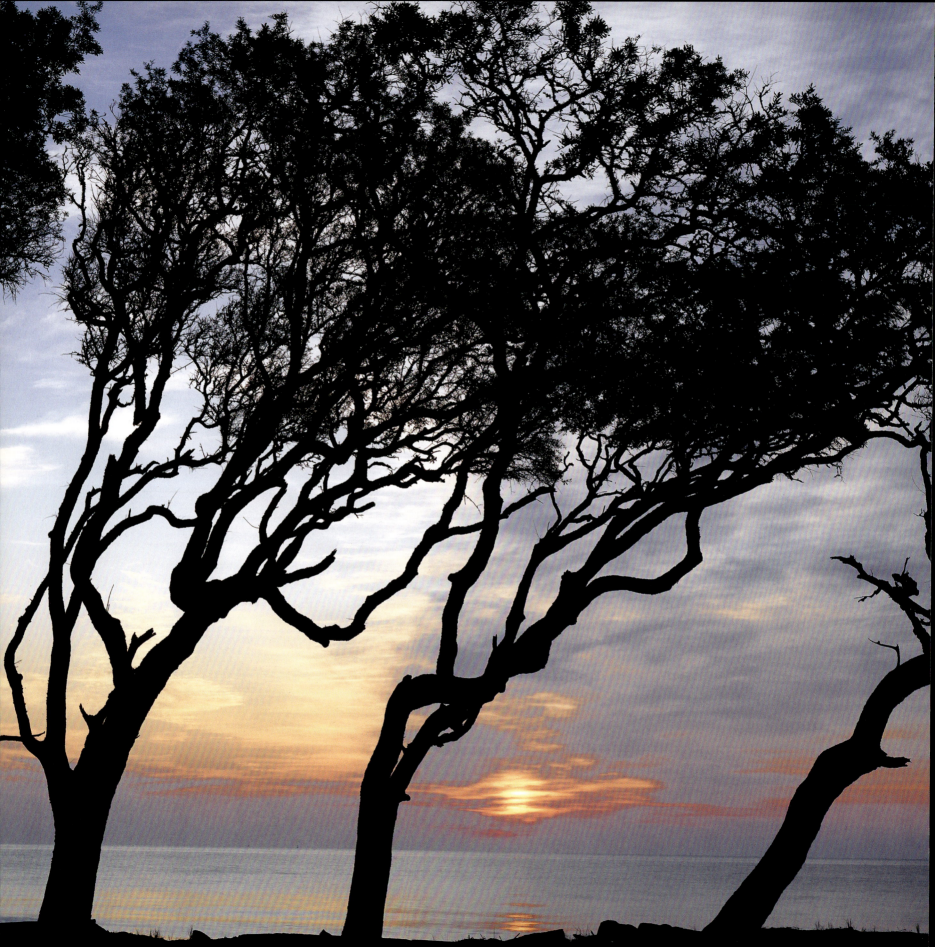

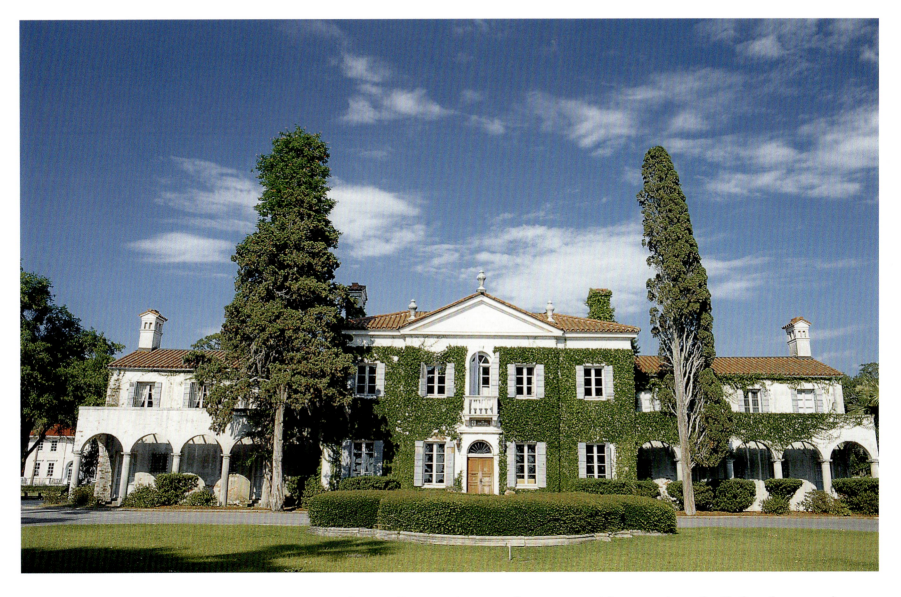

Crane Cottage is one of many seaside mansions built by the members of the Jekyll Island Club between 1886 and 1928. Owners arrived by private yacht, usually from New York.

Tiny Jekyll Island has made a large impression on American history. The Jekyll Island Club—a group of millionaires including Frank Henry Goodyear and William Rockefeller—took up residence here in 1886. In 1910, some of the group drafted the Federal Reserve Act, which helps the government supervise banking and control currency fluctuations.

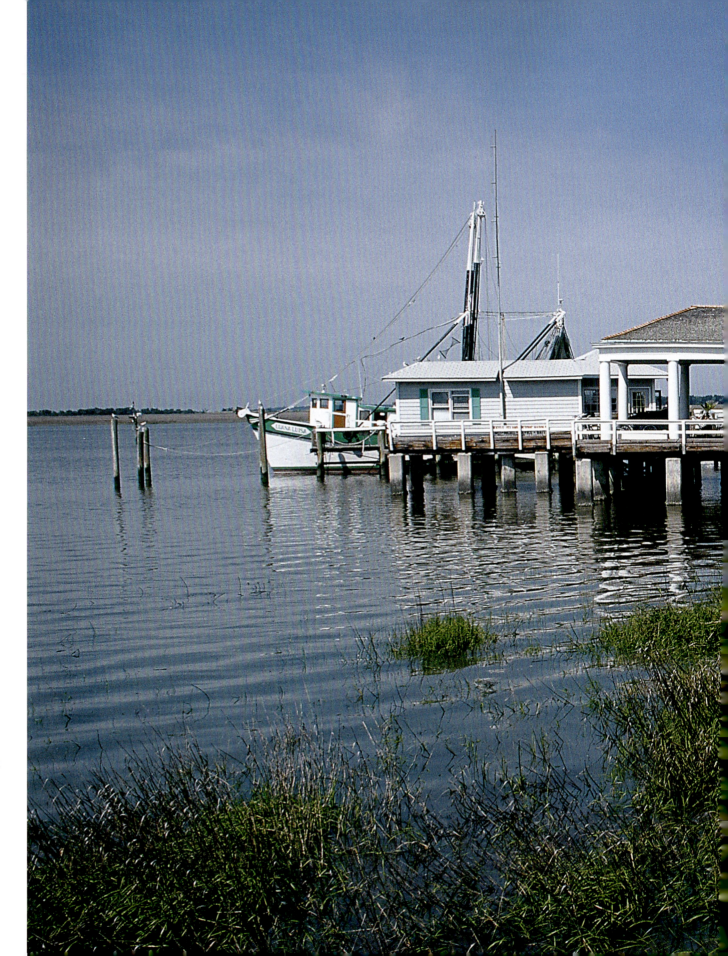

Today, Jekyll Island remains a retreat from the mainland, but it's no longer restricted to millionaires. State laws protect 65 percent of the island as a nature preserve. Hotels, spas, and resort facilities on the remaining land offer a wide variety of recreational activities.

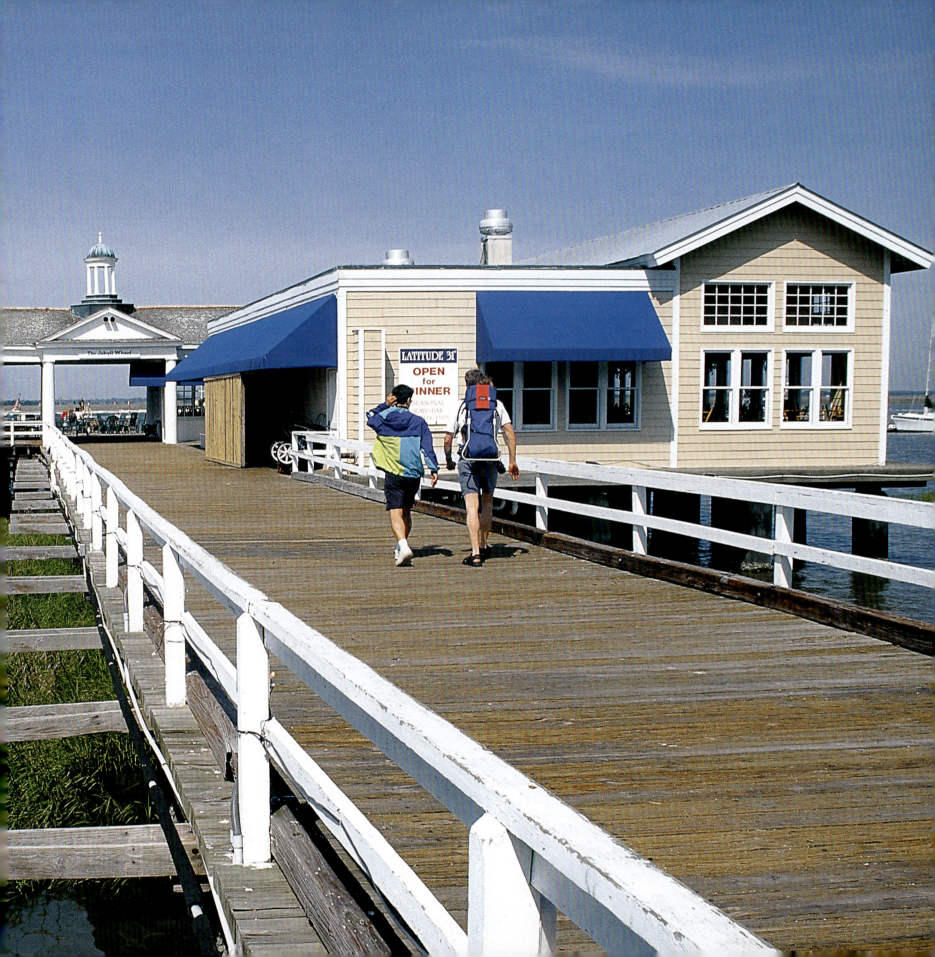

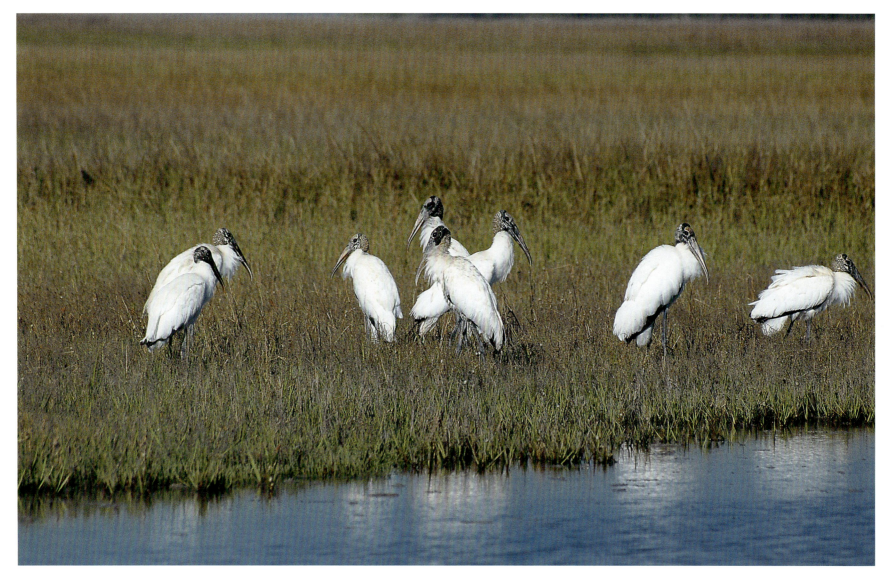

Endangered wood storks, threatened by the loss of their wetland habitat, find refuge in the marshes of Jekyll Island. Along with nesting grounds for native species such as this one, the island serves as a temporary home to migrating birds on the Atlantic flyway.

To the Spanish colonists and missionaries who arrived in the 1500s, St. Simons Island was both a temperate stretch of sand and soil, perfect for settlement, and the home of the Muskogean people, a population considered ideal for religious conversion.

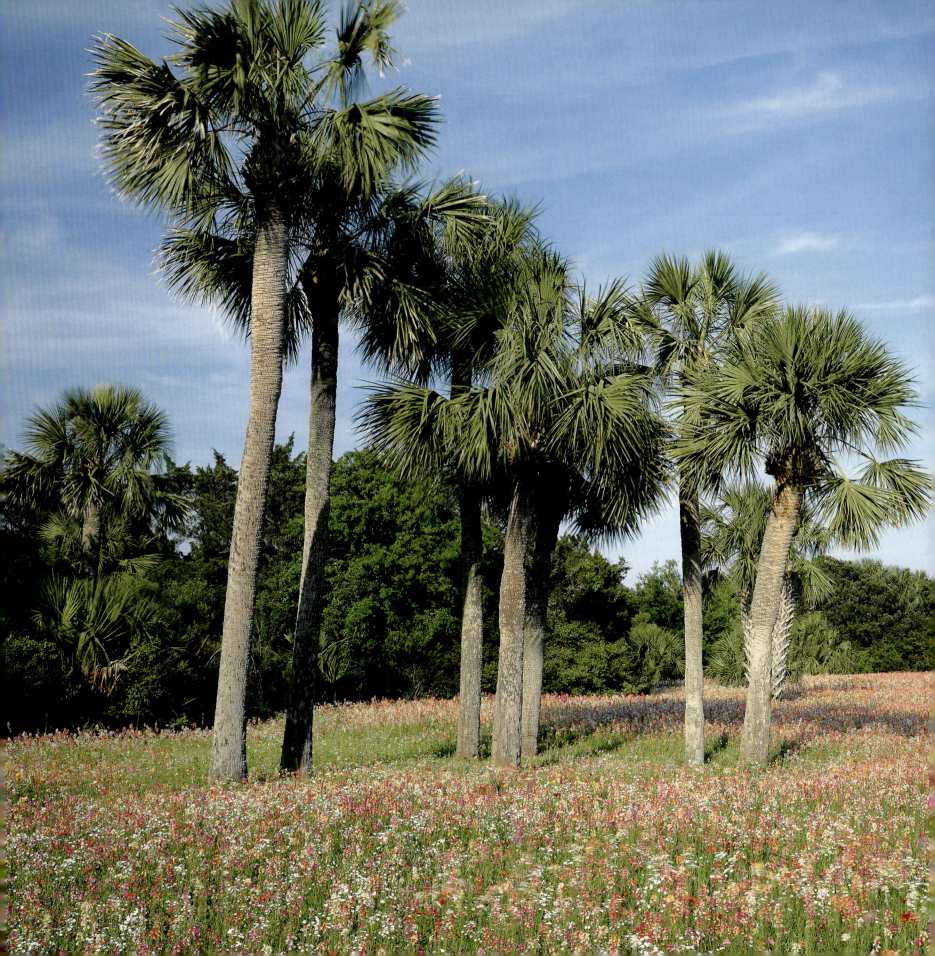

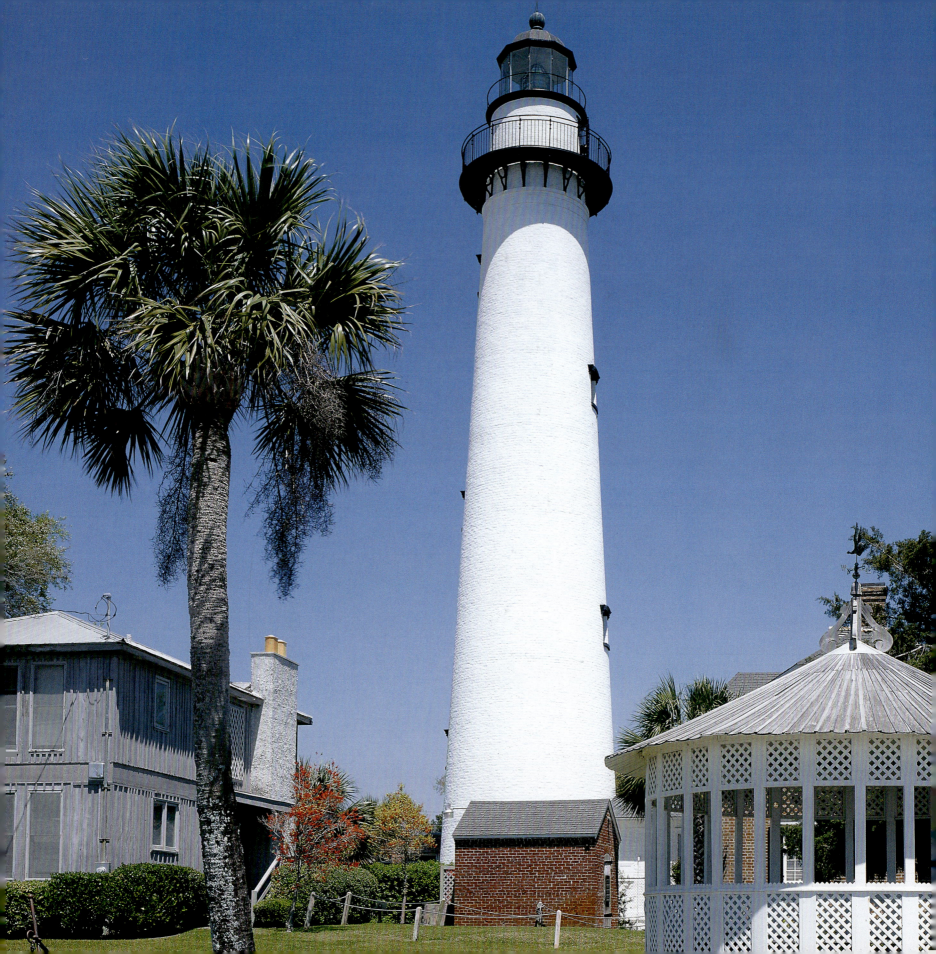

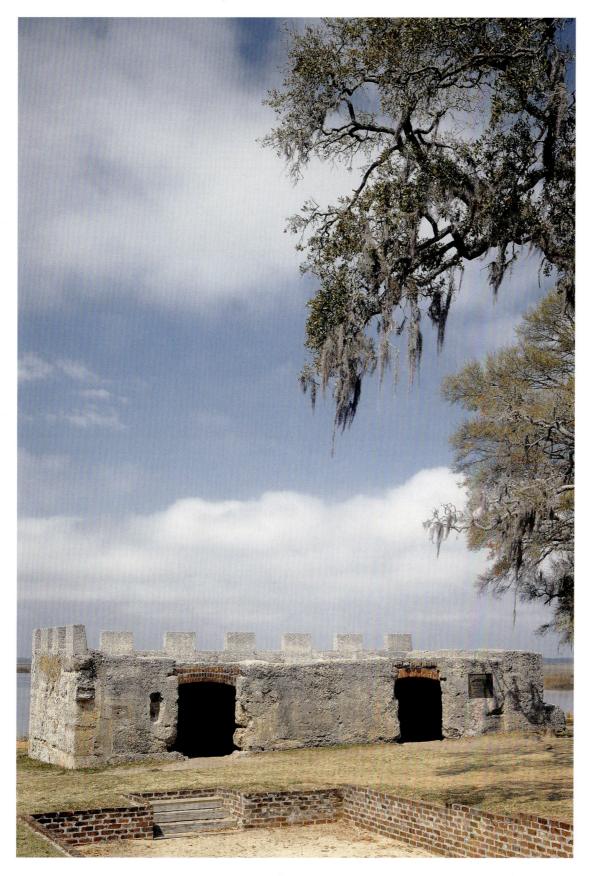

After the British took ownership of the Golden Isles in the 1700s, General James Oglethorpe arrived on St. Simons Island, entrusted with protecting the new territory from the Spanish militia. The remains of his outpost, Fort Frederica, are now part of a national monument.

FACING PAGE—
Local resident James Gould designed the original lighthouse on St. Simons in 1807 and served as its keeper for almost three decades. After the Confederate Army torched the structure in 1862, a new beacon was built just a few steps away. It continues to operate today.

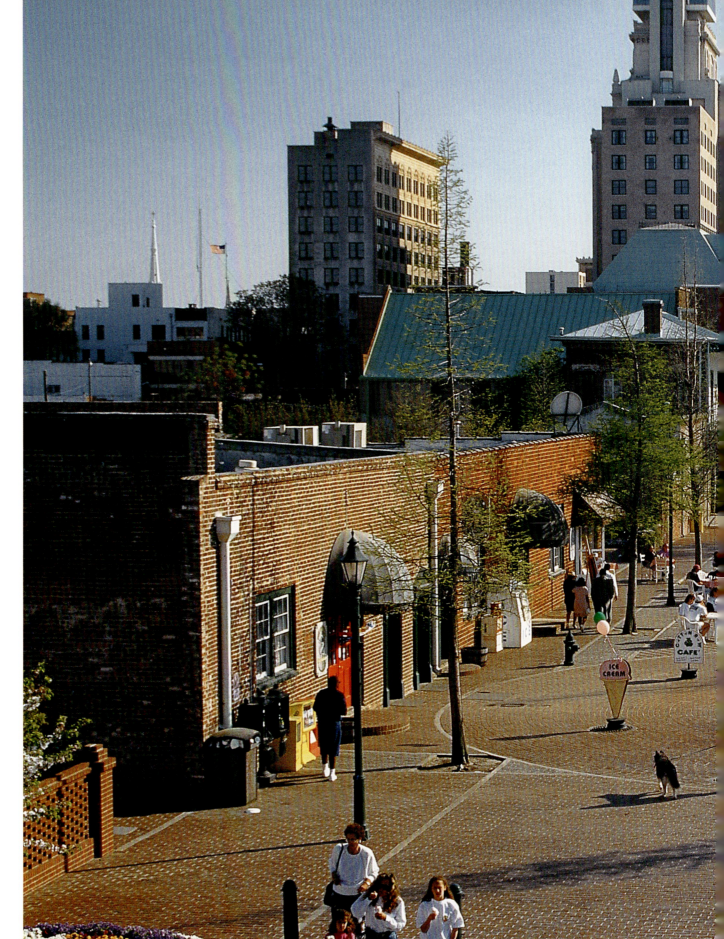

The sights and attractions of Augusta line the picturesque Riverwalk along the banks of the Savannah River. With historic homes and lush landscaping, museums, waterside restaurants, and performance venues, Georgia's garden city offers an endless variety of cultural activities.

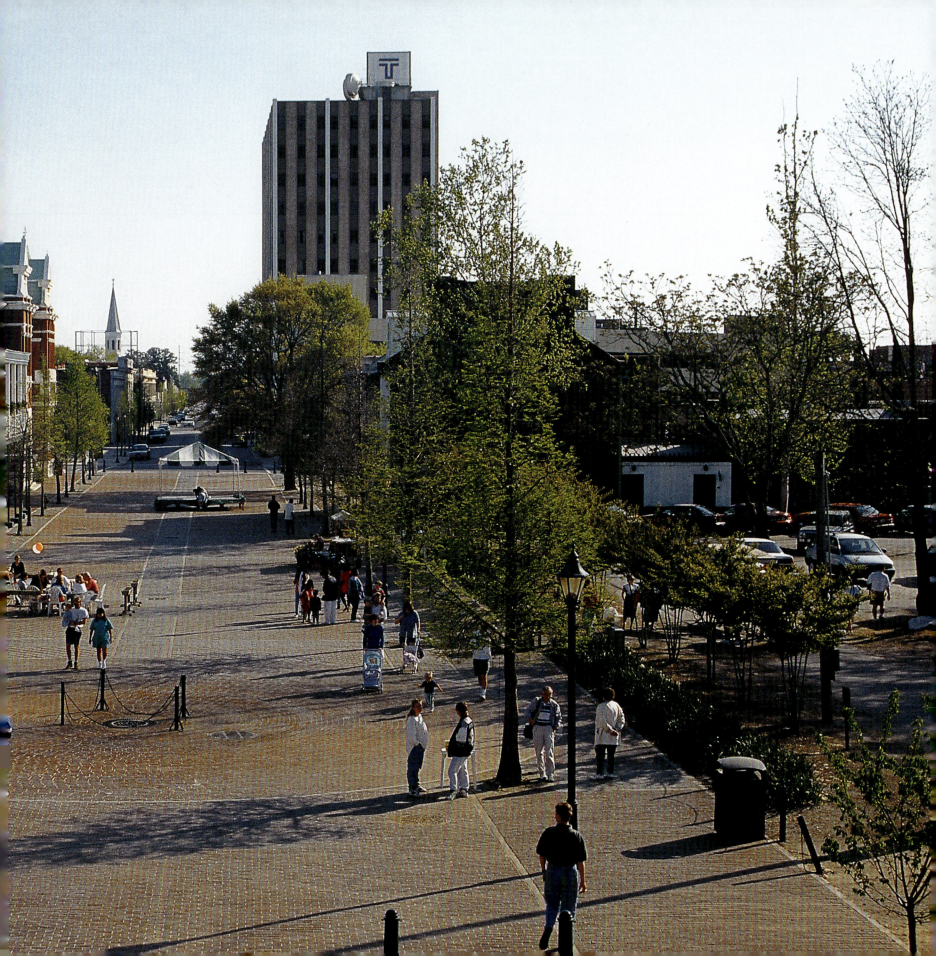

In the 1800s, cotton merchants and brokers— then known as "factors"—met to barter at Savannah's Factor's Walk. Many of the cobblestone paths here were built with rocks brought to Georgia as ballast in English ships. Savannah's noble City Hall is in the background.

FACING PAGE—
Visitors to Skidaway Island State Park can wind their way along the three-mile Big Ferry Trail through this natural saltwater marsh. Oysters, mussels, and clams flourish in the water, herons and egrets stalk among the reeds, and Spanish moss drapes the live oaks above.

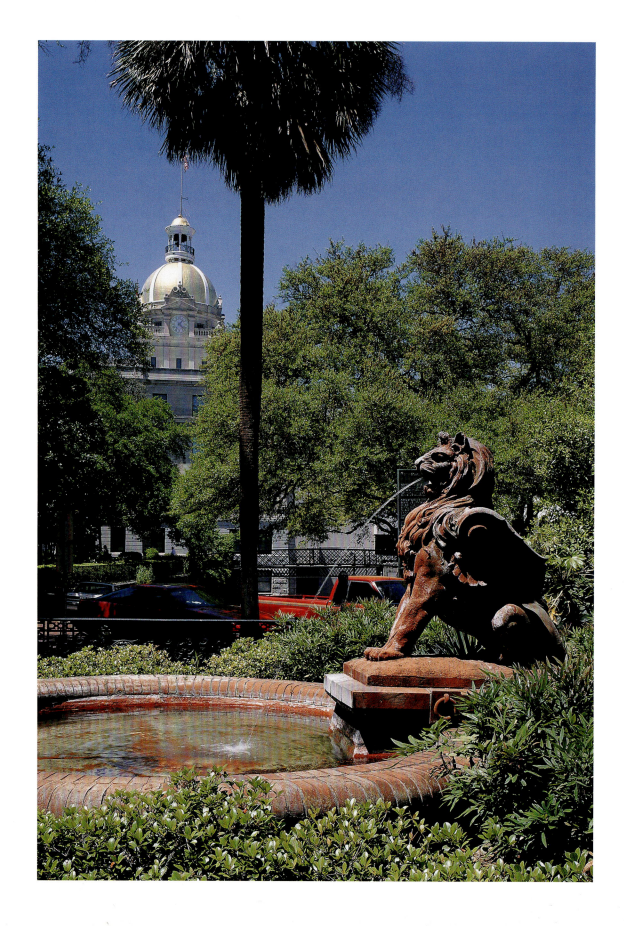

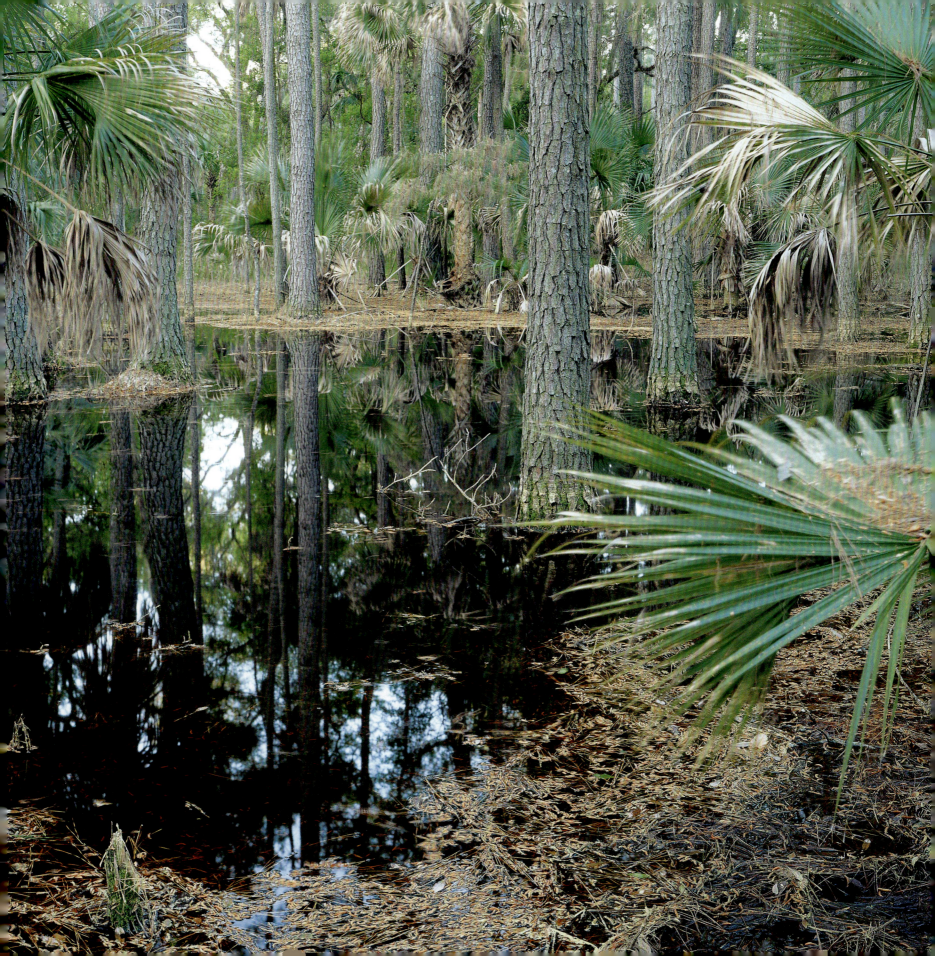

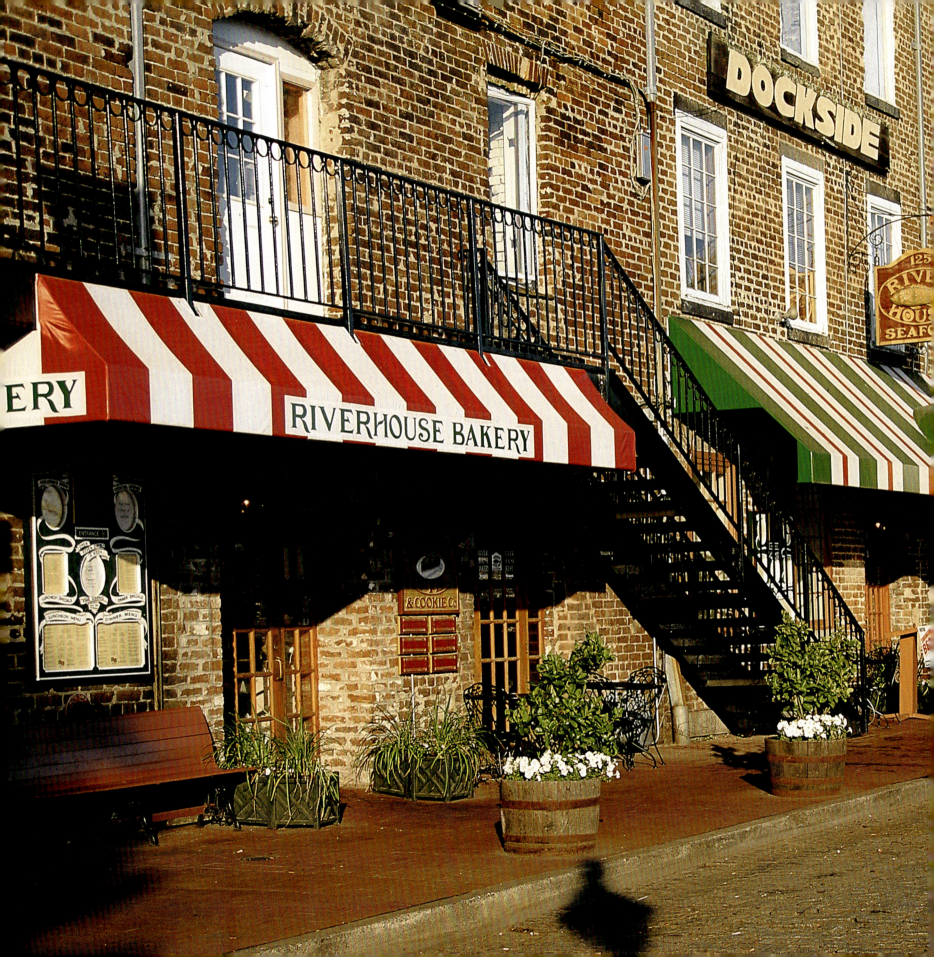

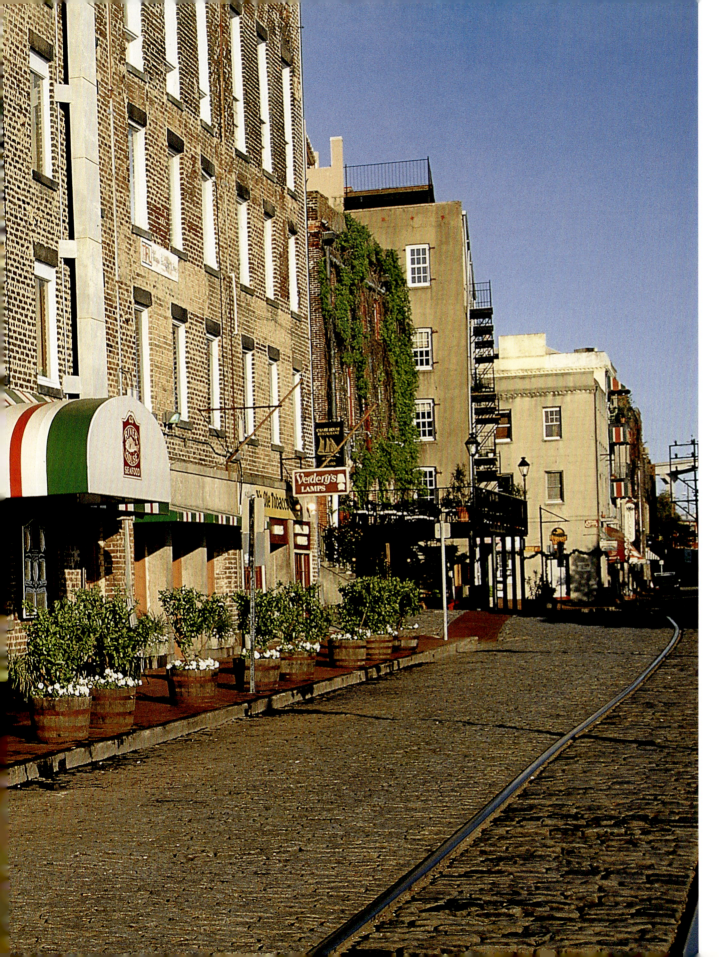

The hidden gardens, historic riverfront streets, and vibrant culture of Savannah combine to entice over 2.2 million visitors to the city each year. More than 50 inns and bed and breakfasts in restored historic buildings cater to these guests.

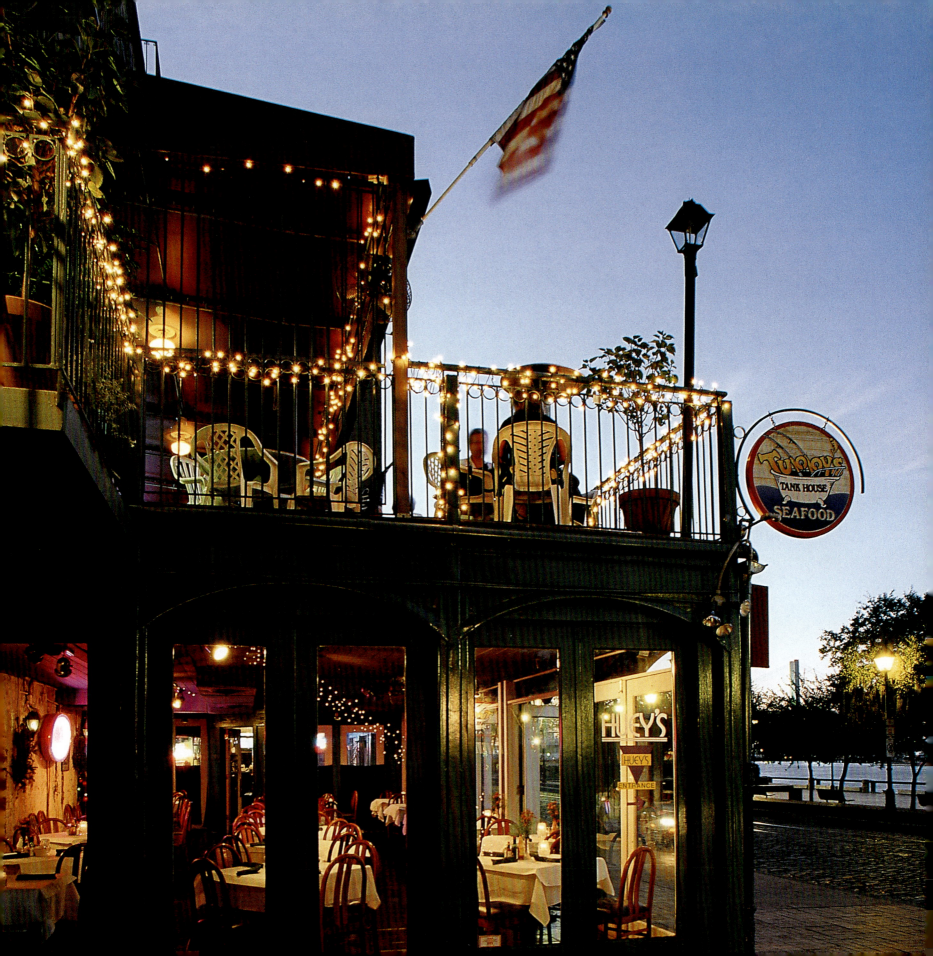

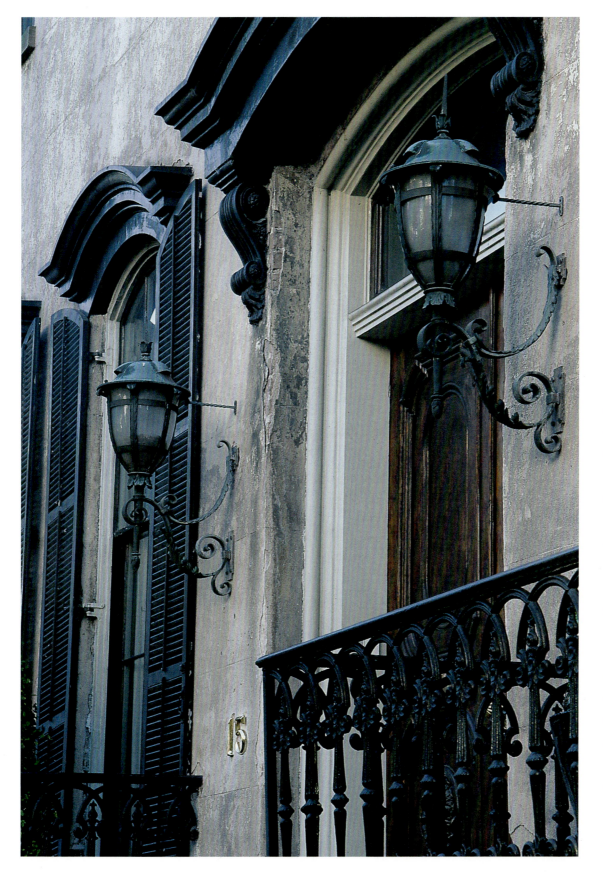

Historic mansions, warehouses, and office buildings, many dating to the 1840s and 1850s, line the streets of Savannah. The city is a collection of 21 stately squares, survivors of 24 squares originally surveyed by General James Oglethorpe when he founded the city in 1733.

FACING PAGE–
The commercial importance of Savannah's river grew exponentially in the late 1700s, until an 1818 yellow fever epidemic caused a quarantine from which local shipping businesses never recovered. The historic riverfront district now offers an array of boutiques and cafés, housed in the refurbished warehouses of the past.

The early wealth of Savannah was built on cotton, a fact that led to the nickname for the Cotton Exchange Building—King Cotton's Palace. Boston architect William Gibbons Preston designed the 1886 building to stand on 10 iron pilings above a boat slip, later transformed into a city street. Since 1974, the building has served as a meeting hall for the local Freemasons.

FACING PAGE—
When it was built in 1733, the Tybee Lighthouse was the tallest in America. A storm destroyed that beacon, erosion threatened the next, and Confederate soldiers ravaged a third. The lighthouse that now stands on the bluffs was completed in the 1860s.

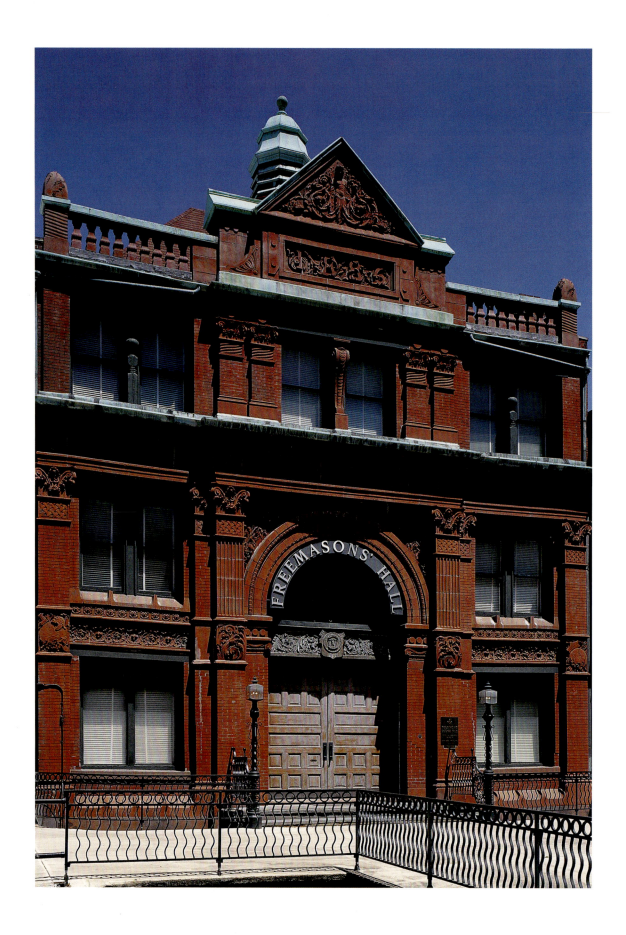

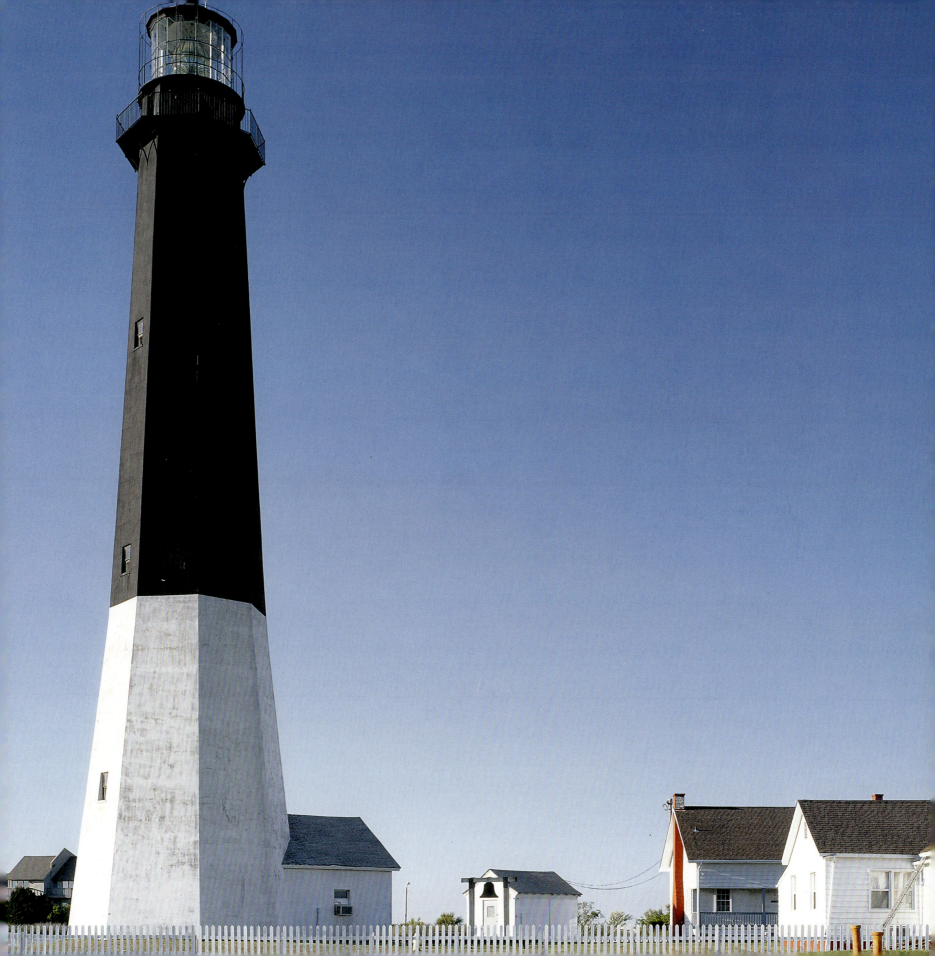

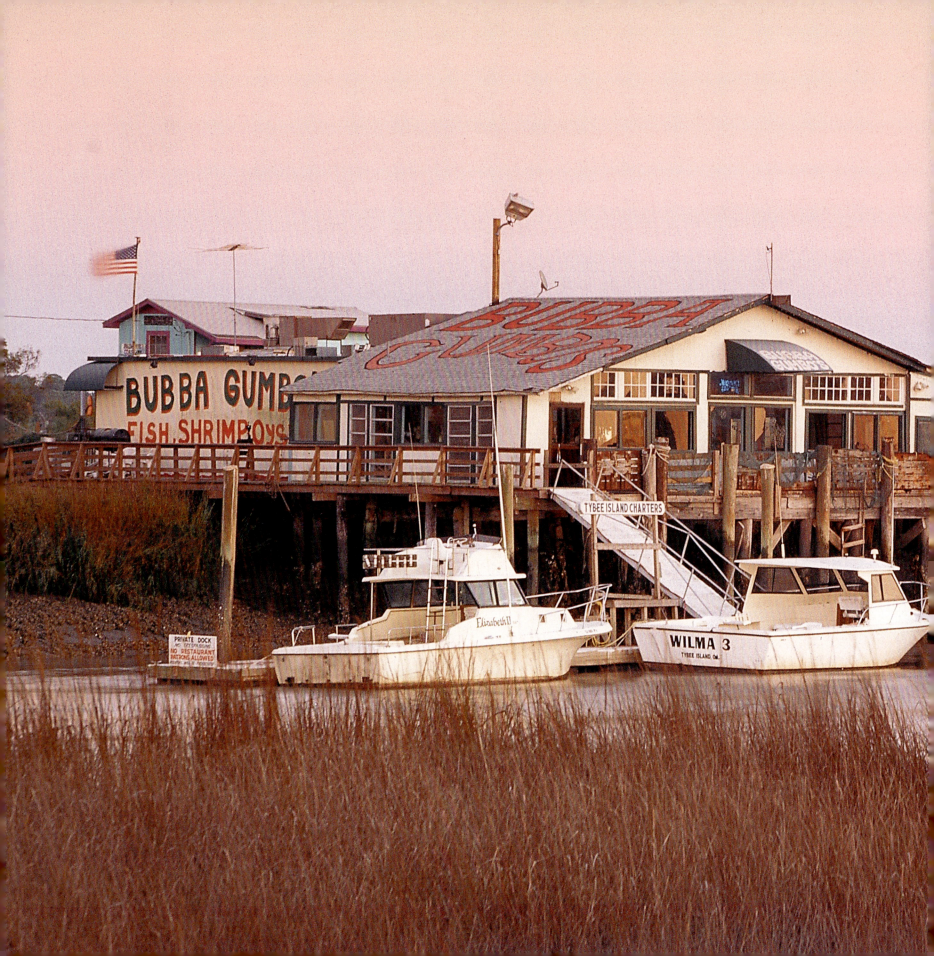

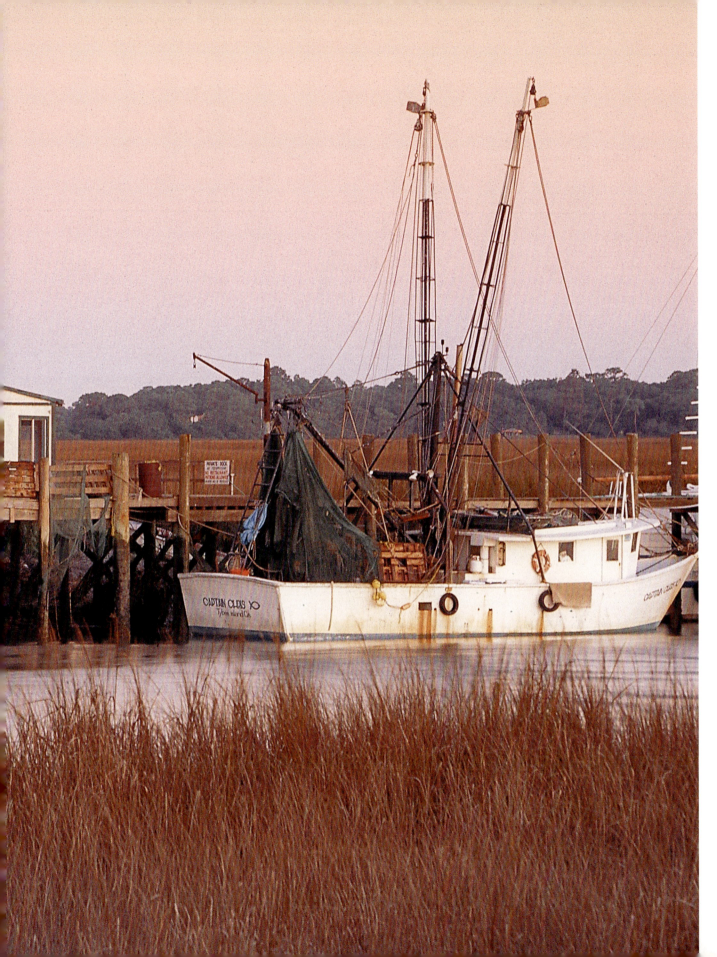

To seventeenth-century French colonists, Tybee Island was a source of medicinal sassafras roots. To the pirates of the time, it was a place to replenish food and get fresh water. To General Oglethorpe and his eighteenth-century British settlers, the island was a strategic outpost overlooking the Savannah River and offering protection to their new settlement.

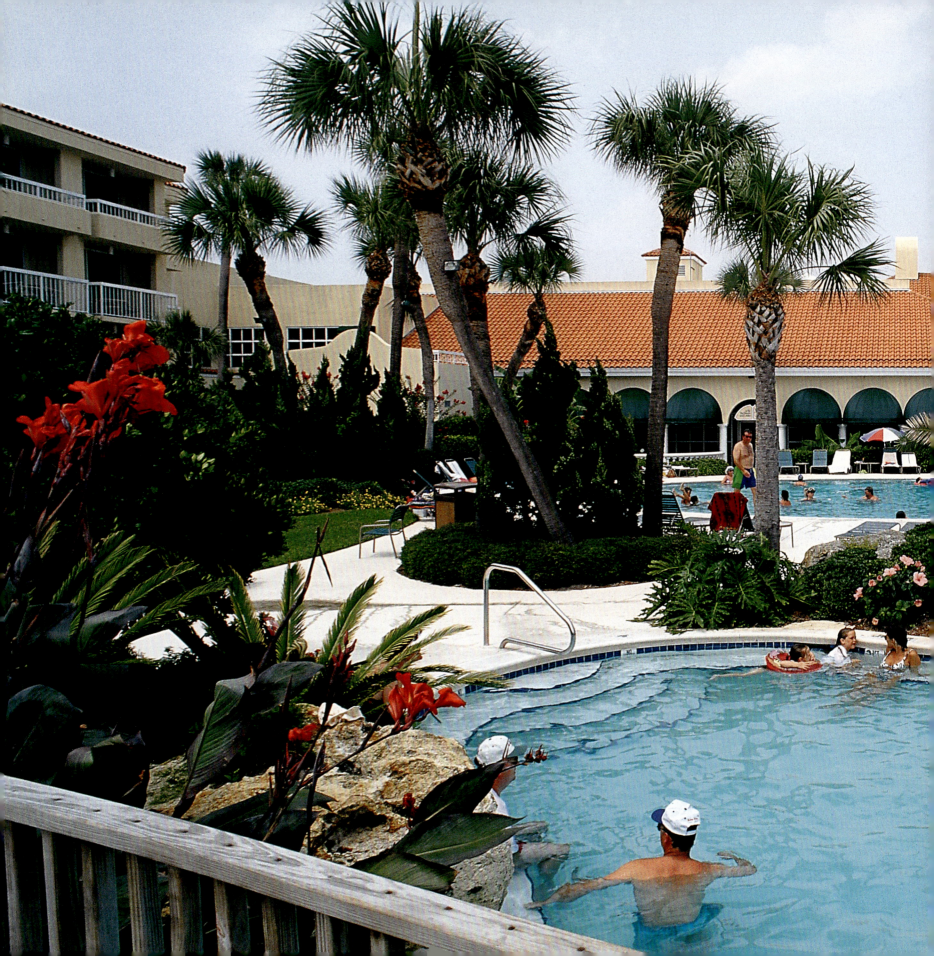

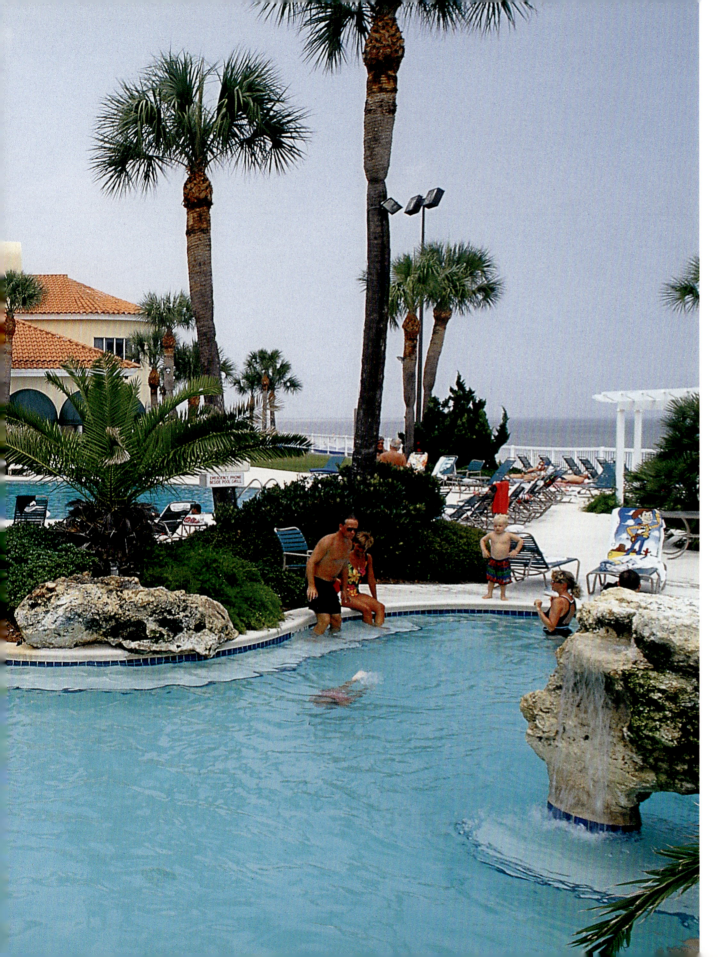

Romantic reminders of plantation life abound on St. Simons, where a warm climate tempered by ocean breezes provides ideal growing conditions. High-quality Sea Island cotton was once renowned across the continent.

The century-old Cathedral of Saint John the Baptist overlooks Lafayette Square. Ten years before the construction of the Square, the Marquis de Lafayette, a supporter of George Washington and American independence, traveled to Savannah and offered his views in a speech. He was so well received that the city named Lafayette Square for him.

FACING PAGE—
The interior of the Cathedral of Saint John the Baptist features riches from around the world— marble from Italy, stained glass from Austria, and rugs from Persia. Though fire destroyed the church in 1898, workers recreated it according to the original plans of the architect, Francis Baldwin.

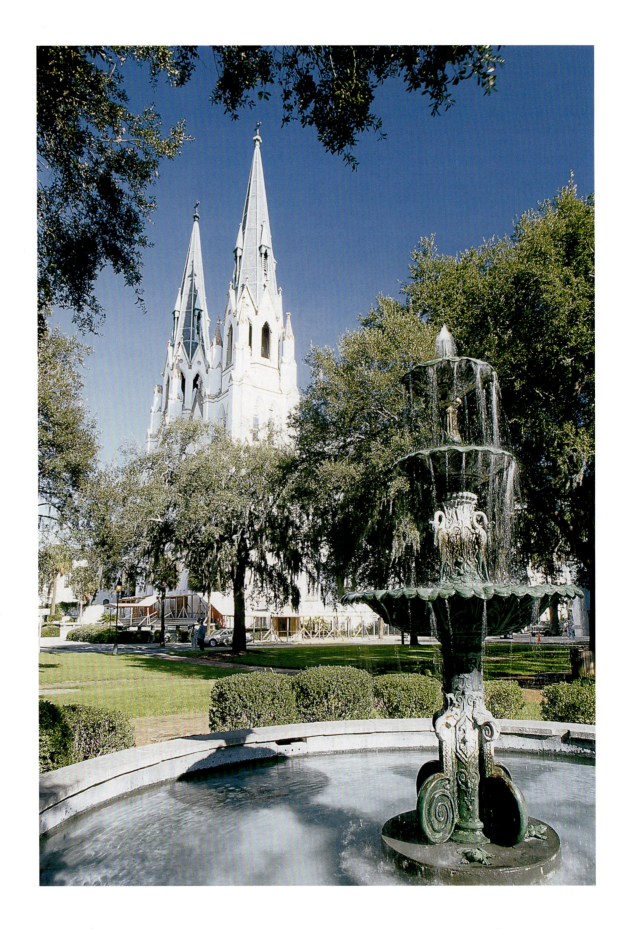

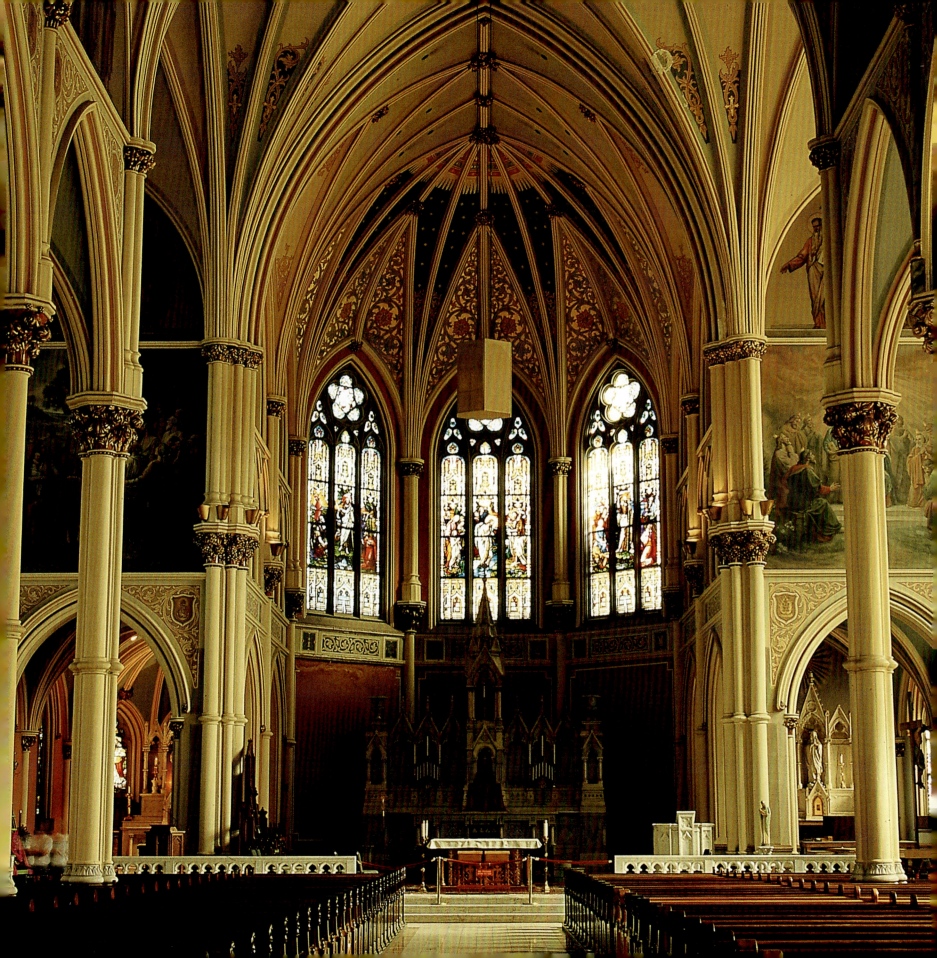

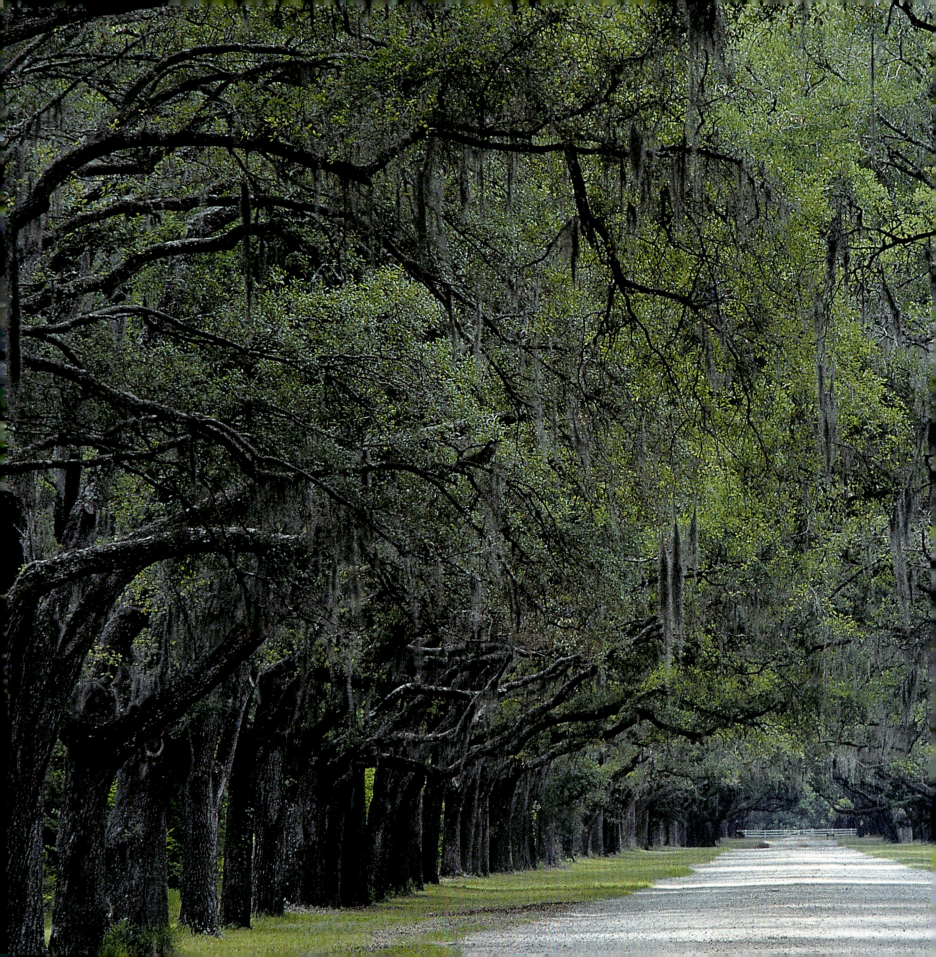

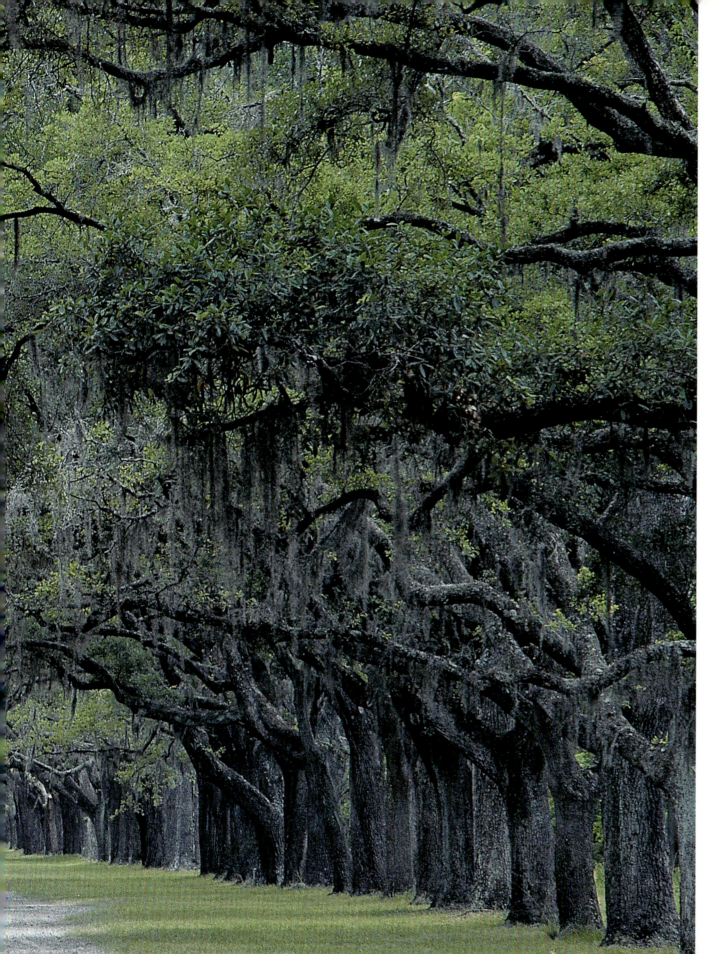

The 400 live oaks that line the drive are the best-preserved part of Nobel Jones's estate, Wormsloe. Jones arrived with General Oglethorpe and served as the colony's first constable, physician, and treasurer. The remains of his home and fortifications at Wormsloe Historic Site represent the oldest reminders of British settlement in Georgia.

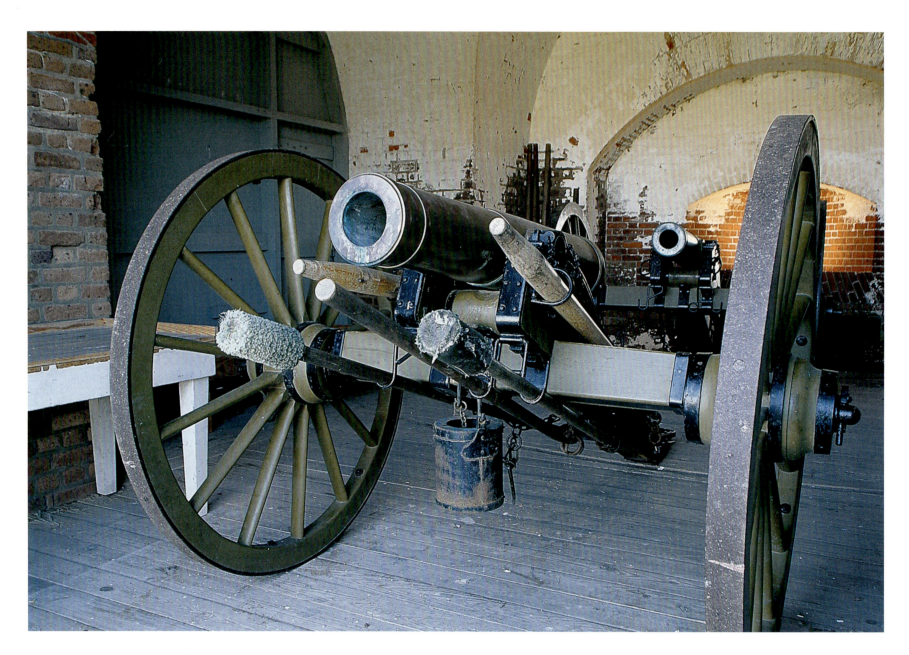

In the 1800s, Fort Pulaski was one of many brick defence posts lining the Atlantic coast. What makes it noteworthy is its capture in 1862 by the Union Army. Firing with a newly developed rifle cannon, troops easily demolished the fort walls. Brick fortifications around the globe were rendered instantly obsolete.

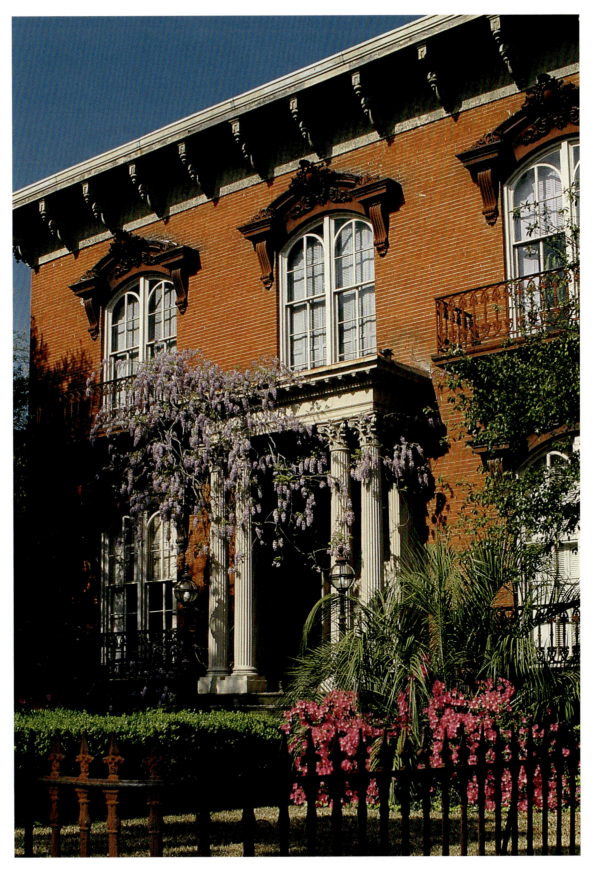

Savannah's stately homes and squares have served as backdrops in many films, from *Forrest Gump* to *The Legend of Bagger Vance*. Most famously, *Midnight in the Garden of Good and Evil* based on a true story— follows an all-star cast on an extraordinary trail through the parlors of nineteenth-century mansions and the historic streets beyond.

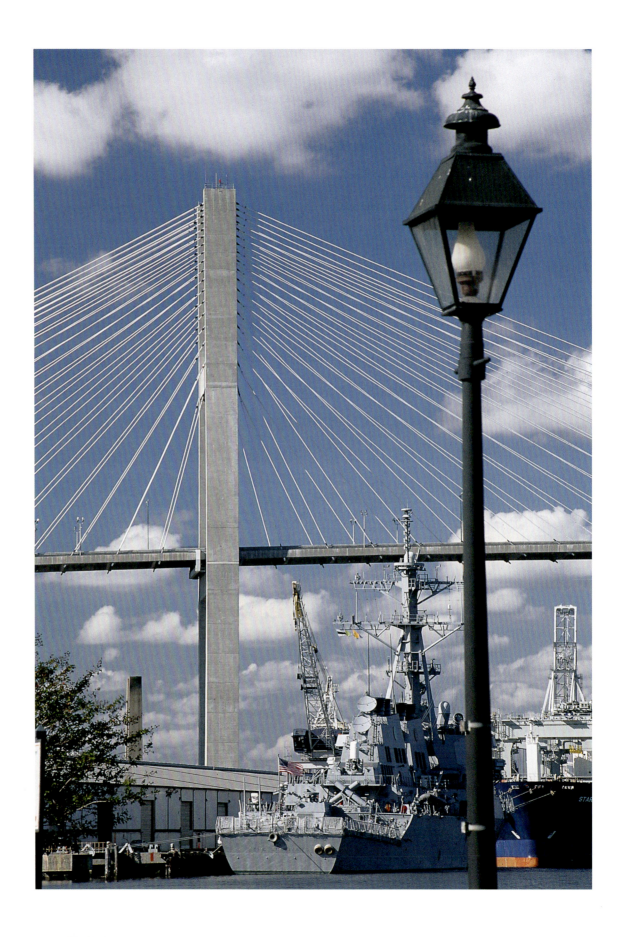

The Talmadge Memorial Bridge arcs 185 feet above the river, allowing ships to pass below. Almost two miles long, the 1991 bridge carries four lanes of traffic across the Savannah River.

Facing Page—
In 1864, Madison resident and former congressman Joshua Hill rode out of town to meet the advancing troops of General Sherman. Somehow, he convinced them to spare his home. As Atlanta and the surrounding countryside went up in flames, the Union forces bypassed Madison and left the community's grand mansions intact.

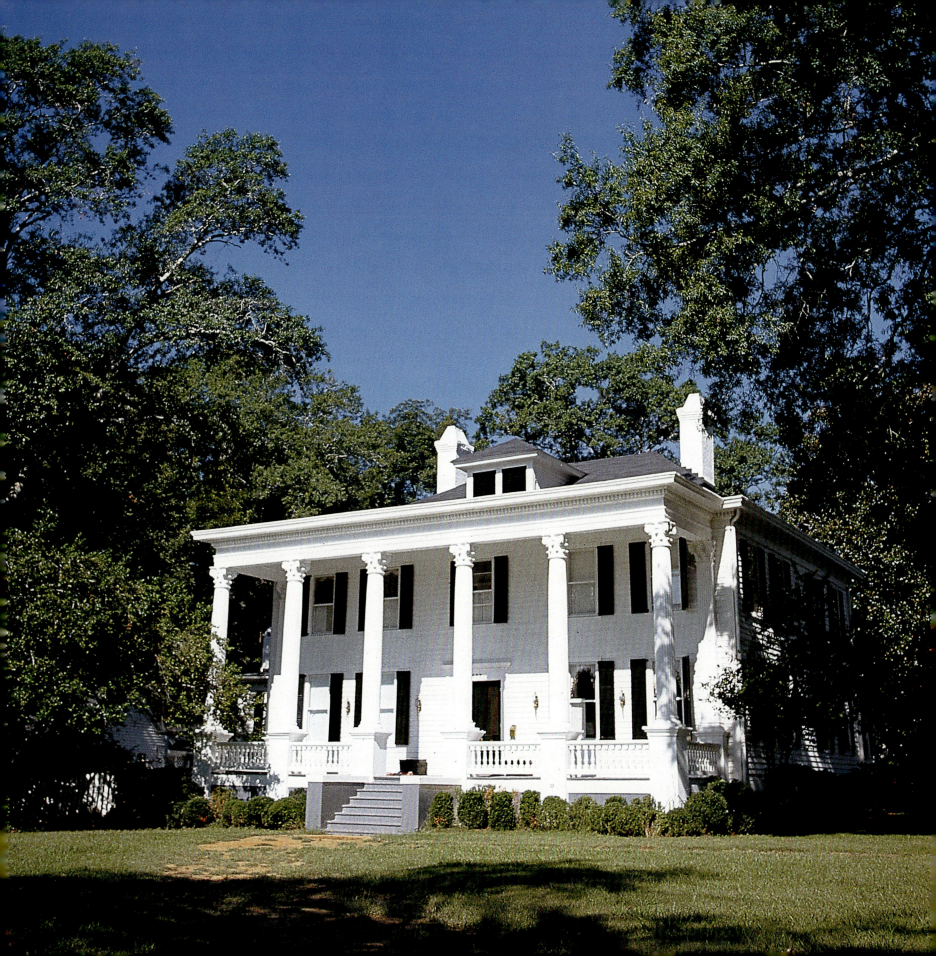

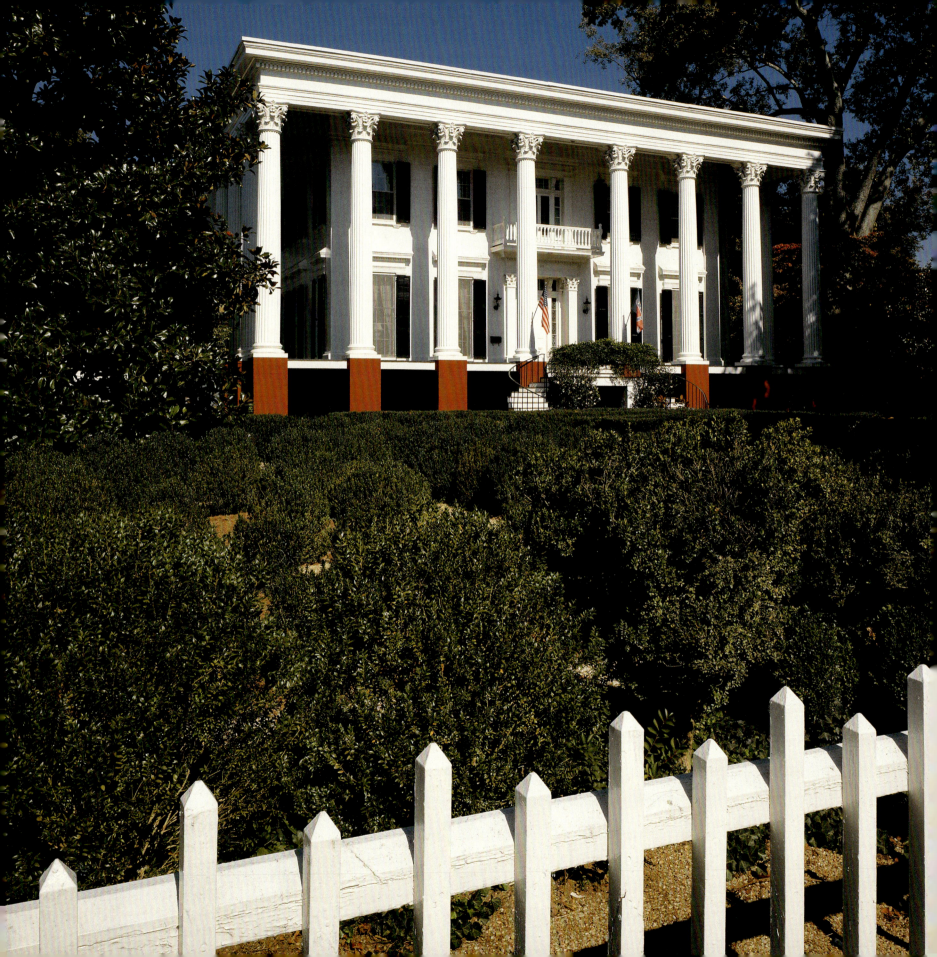

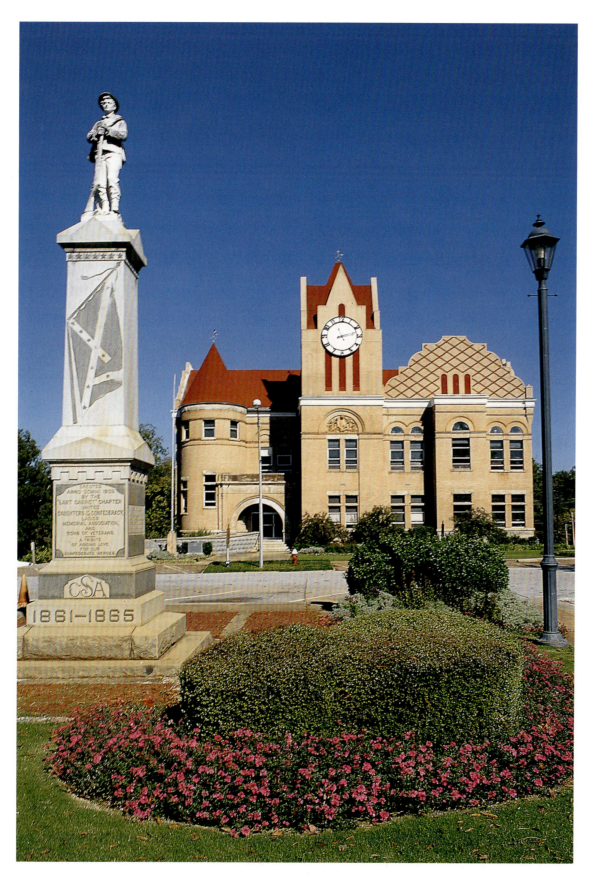

The Wikes County Courthouse overlooks the streets of Washington, Georgia. It was near this site that $100,000 in Confederate gold was stolen as troops attempted to transport it to Savannah. Although suspects were questioned and even tortured, the gold was never found. According to local legend, it remains buried somewhere in Wikes County.

FACING PAGE—
This elegant mansion in Athens is home to the president of the University of Georgia. Founded in 1785, UGA is the oldest state-chartered university in the nation. More than 30,000 students attend classes here in both undergraduate and graduate programs.

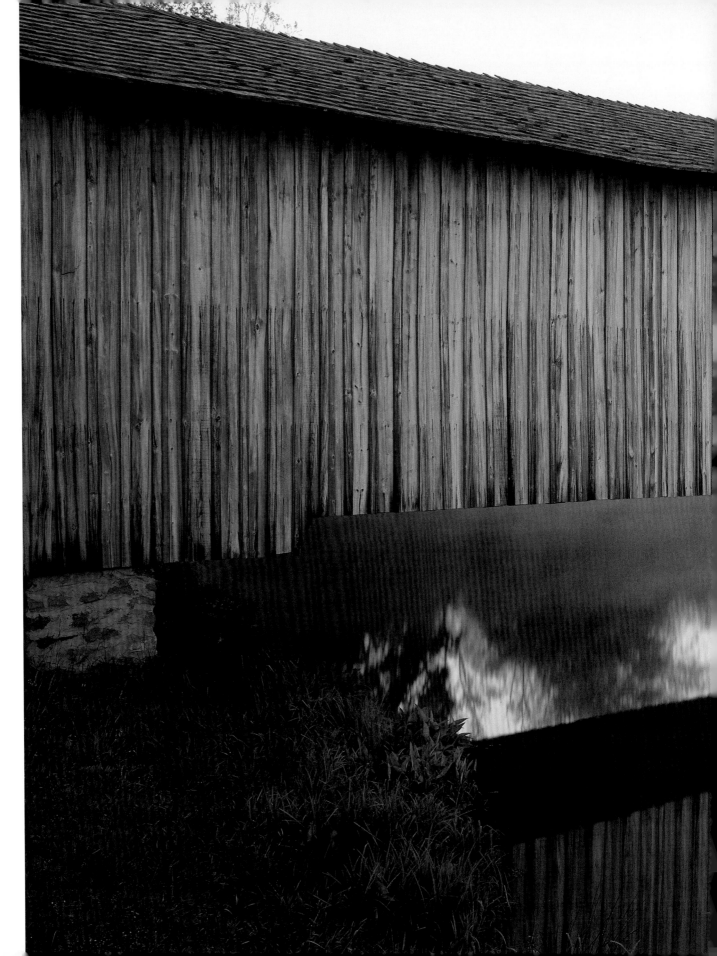

More than 200 covered bridges once linked the carriage roads of Georgia, providing dry footing for horses on snowy winter days. Only 20 of these historic bridges remain. The longest is Watson Mill Bridge, a 229-foot span across the South Fork River, built in 1885 and now protected by a state park.

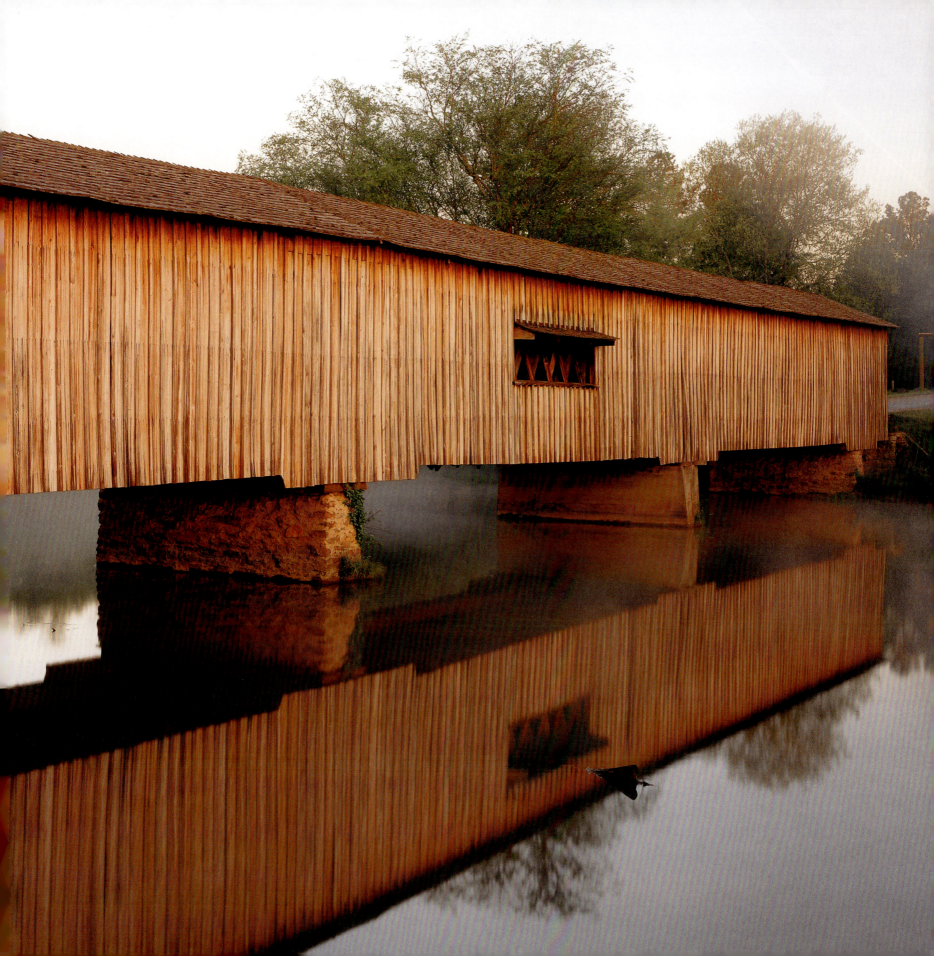

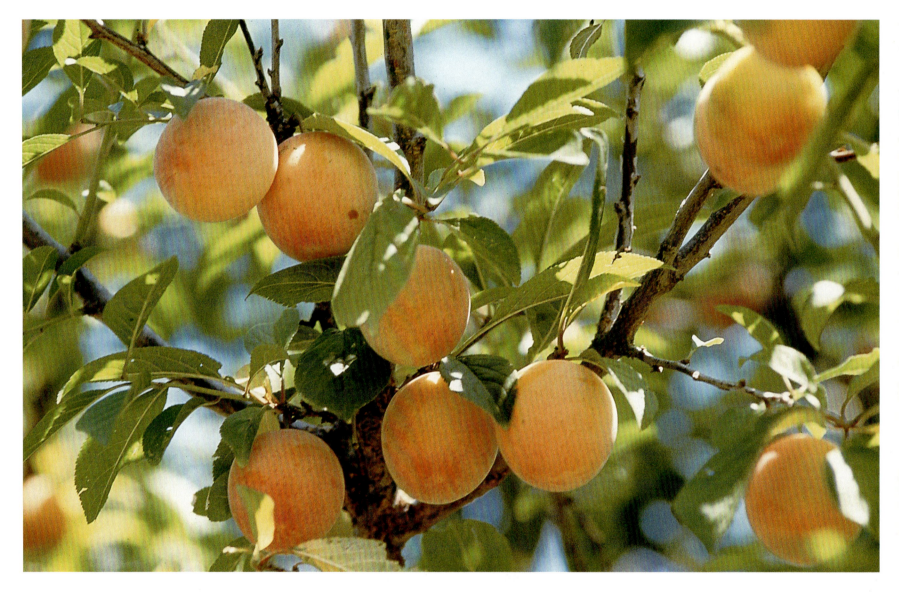

Nicknamed the Peach State, Georgia produces more than 100 million pounds of peaches in an average year, more than almost any other state in the nation. Other leading fruit and nut crops include pecans, apples, grapes, blueberries, and watermelons.

From the forested slopes of the Blue Ridge Mountains and the moss-draped southern swamps to the historic colonial mansions of the interior and the barrier beaches of the Atlantic coast, Georgia's state parks protect a total of 77,500 acres.

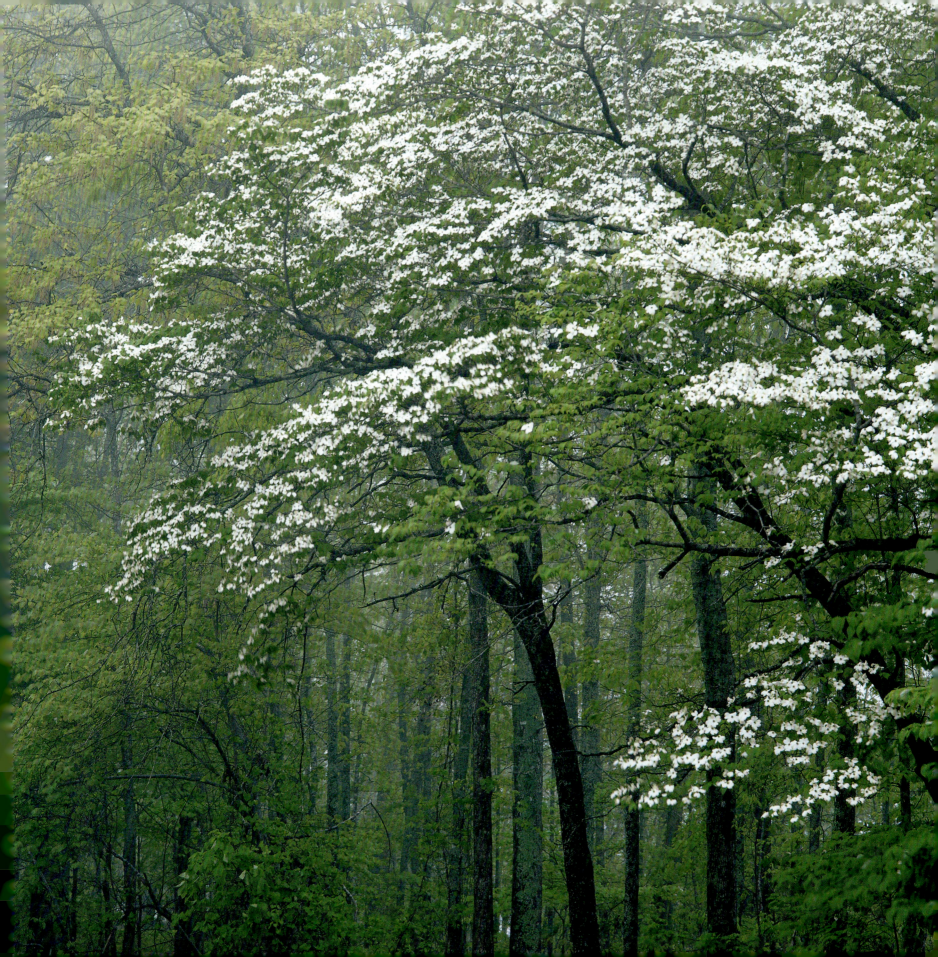

Photo Credits

Richard Cummins/Folio, Inc. 1, 3, 22–23, 25, 28, 30–31, 35, 36, 37, 74, 75, 78–79, 82, 83, 86, 88

Tom Till 6–7, 10, 11, 44–45, 49, 67, 90, 92–93

Terry Donnelly 8, 9, 12–13, 43, 56, 57, 60, 65, 66, 70, 71, 76, 77, 95

Bill Lea/Dembinsky Photo Assoc. 14

Mark E. Gibson/Photri Inc. 15

Robert G. Ginn/Photri Inc. 16

Rob and Ann Simpson/Photri Inc 17

Photri Inc. 18

Jeff Greenberg/Folio, Inc. 19, 24, 54–55, 64

Manny Rubio/Folio, Inc. 20–21

Al Messerschmidt/Folio, Inc. 26–27

Jean Higgins/Unicorn Stock Photos 29, 34, 53, 89

Mark E. Gibson/Folio, Inc. 32–33, 62–63

Andre Jenny/Unicorn Stock Photos 38–39, 41, 42, 48, 51, 68–69

Patti McConville/Dembinsky Photo Assoc. 40, 72–73, 84–85

David R. Frazier/Folio, Inc. 46–47, 61

Bachmann/Unicorn Stock Photos 50

Ken Dequaine/Mach 2 Stock Exchange 52

Richard Quataert/Folio, Inc. 58–59

Bachmann/Photri 80–81

Everett C. Johnson/Folio, Inc. 87

Robin Rudd/Unicorn Stock Photos 91

www.firstlight.ca 94